In Praise of *My Office Today*

John Russell is a longtime creator of powerful images that showcase both the news of the day and the beauty of our good life throughout our Great Lakes state. He has allowed us to understand history-making events and people important to our communities. This is a not-to-be-missed photo journal for every family's coffee table.

SUSAN WILCOX OLSON, media manager of the National Cherry Festival

From a home perch in Traverse City, John Russell has served as one of Michigan's very best sets of eyes for more than a generation.

I was fortunate to meet and work with John more than 30 years ago at the *Traverse City Record-Eagle*. As a young reporter, if I needed to get in behind a police line, or find a back-country shortcut across northern Michigan, or gain access to a Greenpeace boat protesting the old nuclear plant in Charlevoix, John Russell was my connection. John knew everyone. And everyone stopped to talk to him. Always kind and full of energy, John made thousands of news stories come to life with his pictures.

Later in life, John and I have shared new passions. He serves as an excellent photographer for Bridge Michigan, the statewide nonprofit civic news publication I run. And we've shared trout fishing beats (never often enough) on Michigan's famed Au Sable and Manistee rivers.

John is fond of Facebook posts he starts with this line… "My view from the office today…" With each post, he ends the sentence with some fabulous image from his latest adventure.

Enjoy the adventure of this book! We're all fortunate to have John lead us on his ride through Michigan.

JOHN BEBOW, president and CEO of the Center for Michigan and BRIDGE Michigan

As a teenager working summers on our family's farm and orchard in Lake Leelanau and starting to pursue my own journalism career, I often noticed John's outstanding photos in the *Traverse City Record Eagle*. I was impressed and inspired by his beautiful images and considered John the eyes of Traverse City. So, when I became the director of photography at The Detroit News, I was excited to offer freelance work to John. He has since become our eyes in northern Michigan, bringing all his journalistic experience and creative vision to bear, while also pitching and writing many stories for us. Also, he's a wonderful person … kind, curious and hardworking in the tradition of Grand Traverse County. I also consider him a friend, whom I'm lucky to know.

JOHN T. GREILICK, *The Detroit News* director of photo and video

My Office Today

John Russell

Mission Point Press

MISSION POINT PRESS

Published by Mission Point Press
2554 Chandler Rd.
Traverse City, MI 49696
(231) 421-9513

MissionPointPress.com

Edited by Anne Stanton

Cover photo: The North Pier Light in Manistee.
Title page photo: Ann Fleming sits in a one-of-a-kind megaphone at the Boyd B. Barnwell Family Natural Preserve in Afton.

ISBN: 978-1-954786-63-9 (hardcover)
ISBN: 978-1-954786-64-6 (softcover)

Library of Congress Control Number: 2021921334

Printed in the United States of America.

This book is dedicated to my wife and best friend, Meg,
for supporting me through all of my photo adventures.

Sight is a faculty; seeing is an art. GEORGE PERKINS MARSH

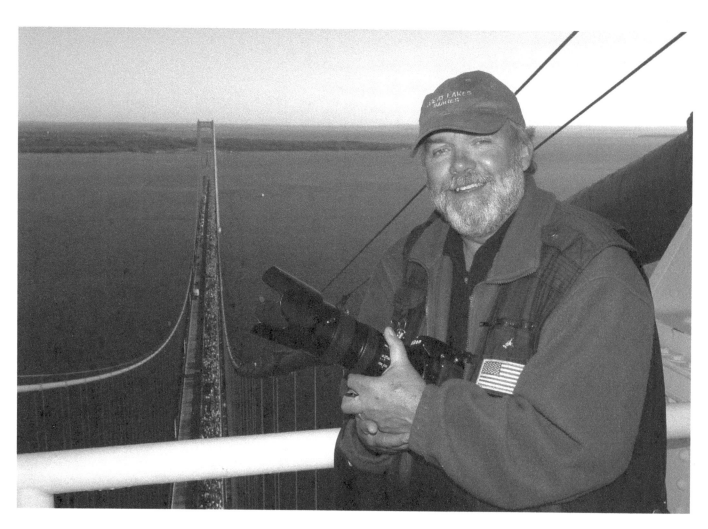

John Russell in his office at the 2008 Labor Day Bridge Walk to Mackinaw City.

Contents

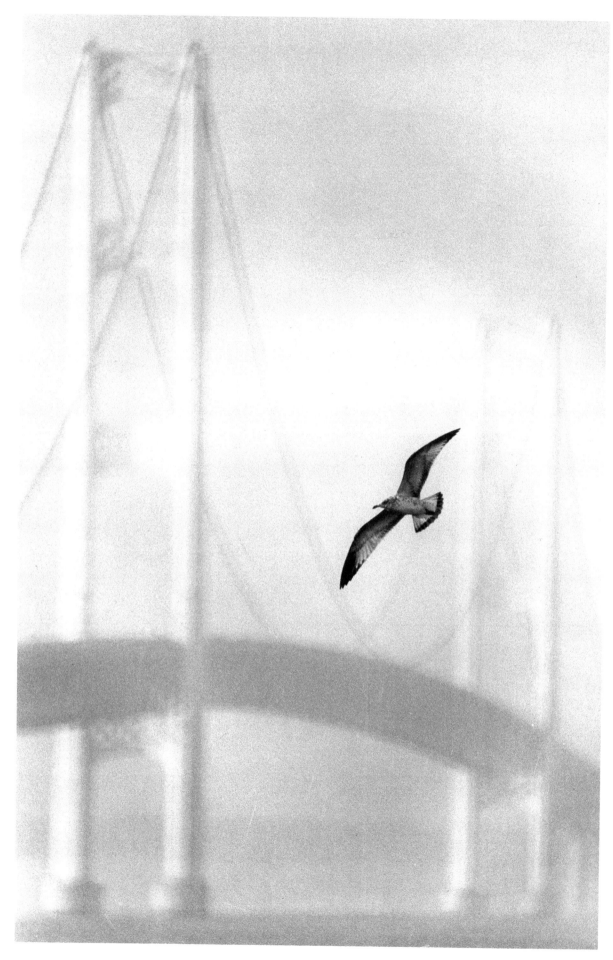

Mackinac Bridge and seagull, 1979.

Foreword

The people and places he's observed,

With photo lens he has preserved.

We're more blessed now than e'er deserved.

I moved to the Grand Traverse area more than 50 years ago. Life was much different then. In many ways, the expanding and nationally acclaimed business and residential development of today have put Traverse City on the map, though many fondly reminisce and think about the laid-back days that we once knew.

Longtime residents recall times when a trip to the Sleeping Bear Sand Dunes, Clinch Park Zoo, or maybe the Hickory Hills ski area, topped the list of things to do. Long before the taprooms and winery tours of today, Traverse City was similar to most other small communities.

Things have changed. According to the latest U.S. Census data, the population of Grand Traverse County has more than doubled since 1970, an increase of more than 55,000 residents. The area is not only a desirable place to live and work, it has also become one of the nation's top tourist destinations with its natural amenities, fine dining and shopping, entertainment, and cultural options.

I'm pleased to introduce John Russell, my longtime friend, co-worker and author of this book. In this photo documentary of Traverse City and the Grand Traverse area, John shares his talents as a photographer and writer while portraying the changes he's witnessed and photographed while living and working in the region for nearly seven decades. After reviewing thousands of pre- and post-digital photos that he's taken, he's included those most interesting and meaningful to him.

John Russell is a native of Traverse City. His life and photographic contributions have become a major part of the fabric of this area. In 2004, he retired as chief photographer of the *Traverse City Record-Eagle* and has since taught photography at Northern Arizona University, Michigan State University, and Northwestern Michigan College in Traverse City. For the past 35 years, John and his wife, Meg, have owned and operated Great Lakes Images, a freelance writing and photography company that serves major newspapers and organizations.

On a personal note, I worked with John at the *Traverse City Record-Eagle* for 20 years, and he earned my utmost respect. John knew how to photographically complement any story, and he consistently and creatively produced images that truly captured the content and exceeded readers' expectations.

Whether or not you're familiar with the Grand Traverse area, I'm certain you'll enjoy this photographic archive.

Zeke Fleet, Retired publisher, *Traverse City Record-Eagle*

Pho-to-jour-nal-ist (noun)
A journalist who communicates events with photographs

Photojournalists are driven, highly competitive, immensely curious, and drawn to the challenge of capturing the moment.

Whether self-taught or college-educated, we possess a good news sense and a good eye, but we must also expertly handle the technology – cameras, lenses, lighting, speed – not to mention the digital filing of each and every photo.

For many, the work evolves into a lifetime of challenge and learning. Most of us are instilled with an abiding devotion to capturing photos that are newsworthy, exciting, funny or beautiful. If we're lucky, our image will create a deeper understanding of our sprawling, inspiring and sometimes tragic world.

Some approach the work as freelance photojournalists, searching out images to be published and viewed by thousands of readers – even millions when the photo is shared nationally or worldwide by wire services.

In past decades, the news holes in daily papers were huge and the challenges relentless to capture and select meaningful images. The photographers at the *Traverse City Record-Eagle*, where I worked from 1975 to 2004, spent a lot of time standing in a darkroom developing film and making prints. For each image, we wrote an accurate caption that quickly told the story.

Digital photography changed our work forever. It has made the capture, editing and delivery of images much quicker. No longer tied to a darkroom, we now carry cell phones and laptop computers, allowing us to transmit images from anywhere in minutes.

Of course, newspapers and magazines are now smaller with less space for images; most have also gone online. But there's still a need for meaningful images, as well as video.

Over the past five decades, I have lived this challenge and still operate under the conviction that my best images are yet to be taken.

Someone asked me after I retired from the *Traverse City Record-Eagle* in late 2004 where my office was that day. I sent them an image of the Au Sable River, where I spent hours fly-fishing. I told her that my office is wherever I happen to be with a camera in hand. At the end of nearly every day, I post my latest photo on social media with the caption: "My office today!"

While editing the images for this book, I was reminded of how fortunate I've been to meet intriguing, smart, good-hearted people, and to capture images that will endure long beyond my own life.

This book has been years and years in the making. I went through some 84,000 photos taken from 1975 to now, choosing photos for their beauty, drama, or historic moment – and always – for the intriguing story behind the image. I hope you enjoy each and every one.

John Russell

BREAKING NEWS

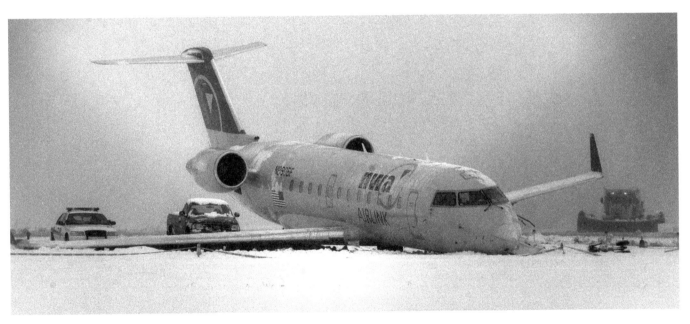

Jet Skids off the Runway

A Northwest Airlink jet flying in at 1 a.m. from Minneapolis in the middle of a snowstorm veered off the runway and skidded to the end of Runway 28 at Cherry Capital Airport, April 12, 2007. The 49 passengers and crew on flight 4712 were not injured, and the Federal Aviation Administration investigated the incident.

Railroad Pretzel

On a warm August evening in 1981, a call came across the scanner about a derailed train in the village of Fife Lake. Seven cars, part of a 36-car train, came off the tracks along the shore of Fife Lake. Unaware of the derailment, the engineer continued north, heating the rails until they bent like a pretzel. A tree pushed over by the rails crushed Robert Kitchin's fishing boat. I imagined it would be the oddest claim ever attached to a railroad accident. Quirky situations like this one have made my work fascinating and fun.

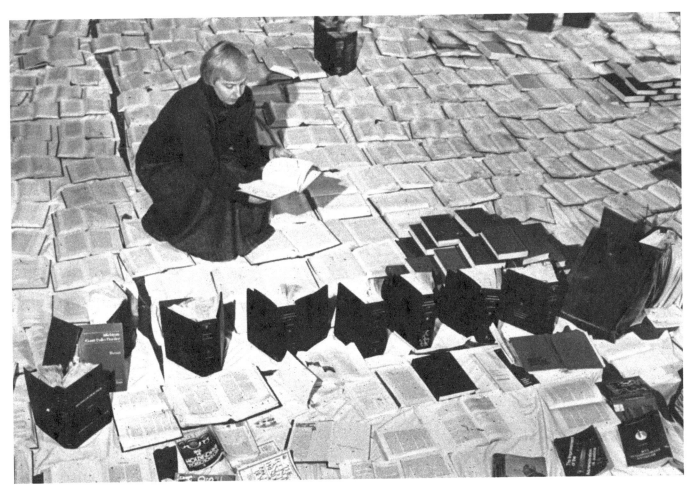

Betty's Books

Michigan Supreme Court Justice Elizabeth "Betty" Weaver turned law book pages in the Glen Arbor Township Hall in 1987. A fire in an office next to her law firm had flooded the library, and books were laid out to dry on the floor. Pages were turned occasionally to prevent them from sticking together.

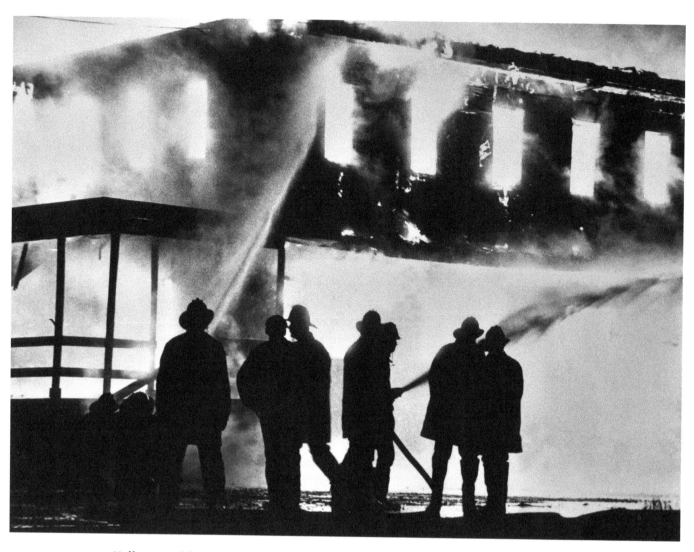

Kellogg Building Supply Goes Up in Flames

I was playing tennis at Northwestern Michigan College on May 31, 1977, when we heard loud and continuous sirens. A massive fire at the Kellogg Wholesale Building Supply warehouse was raging, drawing me immediately away from my tennis game to get some photos. Cass Road was closed for hours as firemen from several departments worked the blaze.

The entire news print supply for the *Record-Eagle* was destroyed with damage estimates totaling around $1.3 million. After two phone calls, the *Cadillac Evening News* agreed to immediately send over some newsprint paper on an open truck so the *Record-Eagle* could continue publishing until a new shipment was delivered. Thankfully, it wasn't raining.

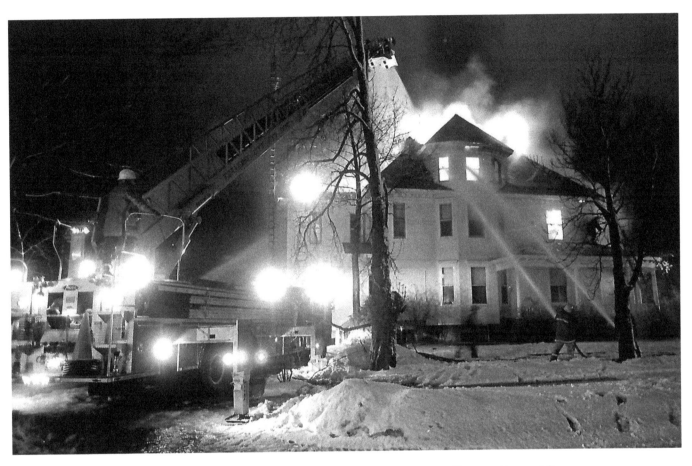

Morgan House Aflame

Morgan House, a 100-year-old Victorian home in Traverse City, caught fire the morning of January 17, 1989. An adult foster care resident came home drunk and intentionally started the blaze in a dumbwaiter.

I was so interested in examining the extensive water hoses and ladder truck that I fell on my butt, slipping on ice created by the exhaust of said ladder truck. I wasn't hurt (aside from suffering a little embarrassment), but the house was heavily damaged by fire and water. It has since been restored and once again brightens the neighborhood.

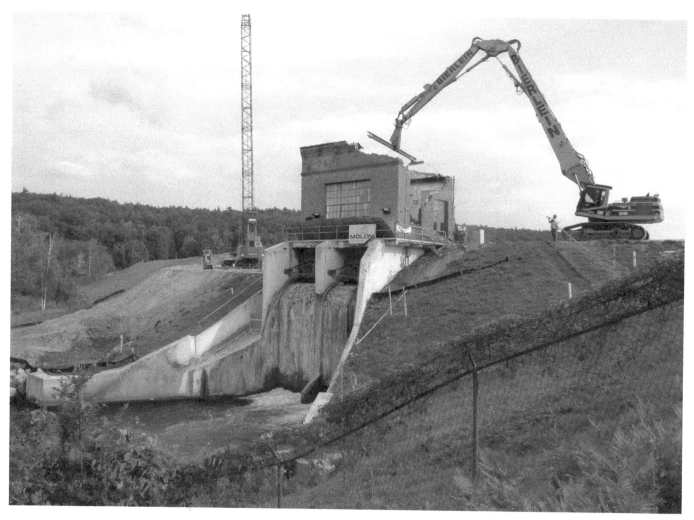

Brown Bridge Breach

The Boardman Dams Removal and River Restoration project was created to remove three of the river's four existing dams to return the river to its more natural state. The first dam slated for removal was the Brown Bridge Dam, built in 1921 and made of concrete and earthen materials.

I was the only media there that day, watching as the steel drawdown structure was opened on October 6, 2012. In fact, I had followed the entire deconstruction of the aging structure owing to my love of the Boardman River, where I like to fly-fish and relax.

The drawdown was intended to slowly drain the last of the already depleted pond, but I watched anxiously as the downriver water swelled rapidly. My original plan, when I'd arrived, had been to wade in the river below the drawdown. But Steve Largent, a river keeper and project participant, allowed me to shoot from a corner of the structure with no idea of the chaos ahead: massive flooding, evacuations and destruction. He may have saved my life.

Two hours after the breach, I was invited onto a U.S. Coast Guard helicopter to get aerial shots of the flooding.

(Above) The power plant came down in August 2012.

6

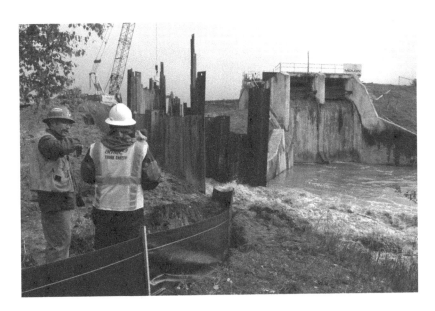

Engineers watched as water was released from the Brown Bridge Pond.

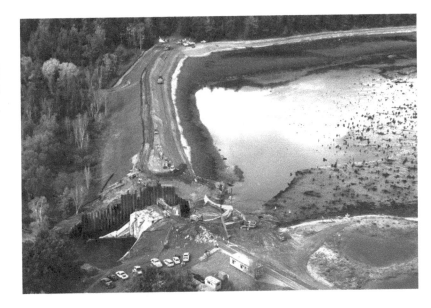

The U.S. Coast Guard allowed me to capture aerial photos to show the devastation.

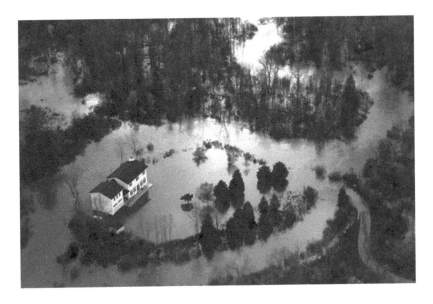

Flooding downstream inundated homes and bridges.

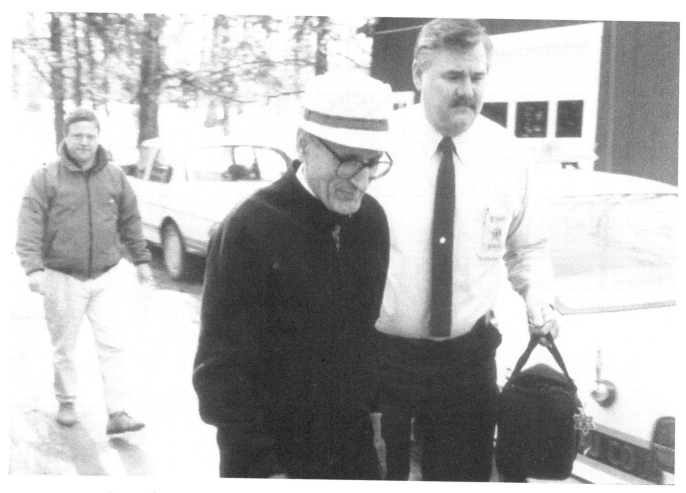

Dr. Death

Here is a shot of Dr. Jack Kevorkian, a champion of a terminal patient's right to die. It was midday, February 1993, when he was escorted by Leelanau Detective Sgt. Robert Mead and former Leelanau County Prosecutor Tom Aylsworth after helping Leland resident Stanley Ball, 82, and Mary Biernat, 73, from Crown Point, Indiana, end their lives.

The timing of this photo was fortuitous. I was already in Leland enjoying lunch with my wife, Meg, when paged about the event. Because I often went ice sailing with Stanley Ball's son, David, I knew the location of his father's home and immediately drove over. I arrived just in time to capture images of the doctor leaving the Ball residence with law officials.
As I was pulling out of the driveway, journalists were just arriving, probably surprised to see I'd already gotten my shot.

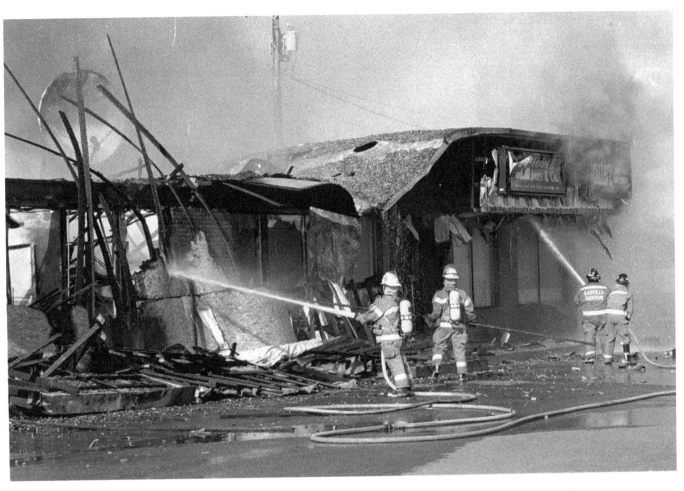

Hickory Corner Destroyed

I was building a picket fence in the front yard of our Elmwood Street home in May 1994 when I heard sirens. Lots of sirens.

I went inside and heard on the police scanner that Hickory Corners on Fourteenth Street was ablaze. My wife, Meg, and daughter were shopping and had my gear in the Jeep. I contacted Tom's Food Market; they had her paged and I quickly told her what was happening. With no time to spare, she abandoned her shopping cart, zoomed home to pick me up, and delivered me to the site within 15 minutes. The entire strip of businesses was on fire with the blaze moving rapidly. I snapped this photo and built the rest of the fence later. Meg and I make a great team.

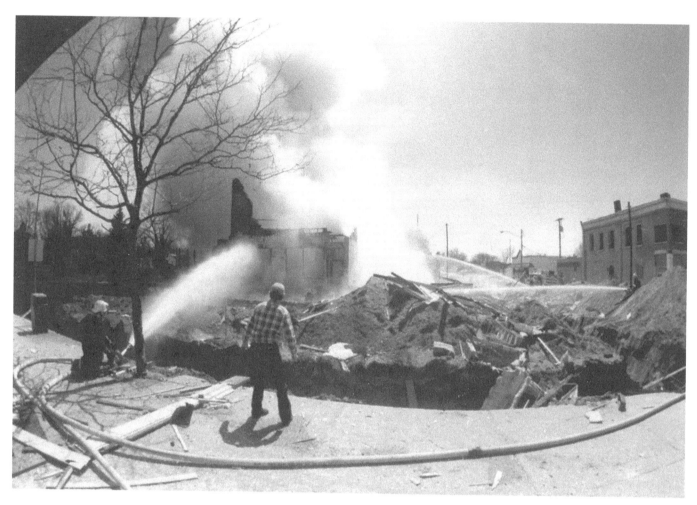

Mancelona Street Explosion

On an April Sunday in 1995, I was visiting my father-in-law on Elk Lake when I saw a rapidly expanding mushroom cloud of smoke to the east across the lake. From the excited buzz on my car's police scanner, I heard there had been a huge explosion in Mancelona's downtown and was the first media person on the scene. The blast was caused by leaking gas from a sidewalk renovation project.

Earlier in the day, someone had smelled the leaking gas and contacted the company. But by the time an employee arrived to check it out, it was too late. An entire block had already vanished.

Oilman Red Adair Versus Oil Well Fire

An oil well near Waters, Michigan, failed and ignited into a 300-foot flame in May 1976. To extinguish the fire, a large area was cleared of trees, and a mile-long water line was constructed by Red Adair.

Adair was a hot shot, world-renowned oilman from Houston, who brought in a team of experts. After a month of preparations, the fire was extinguished. At its height, flames could be seen as far away as Traverse City, 48 miles away.

(Below) Water cannons sprayed the burning sand and area around the wellhead, cooling the area so a new well head can be placed.

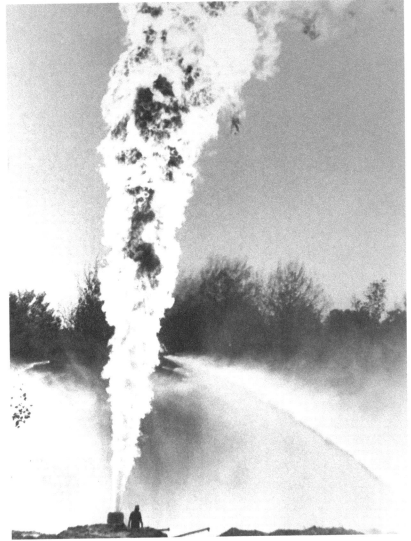

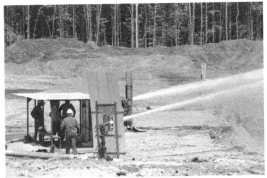

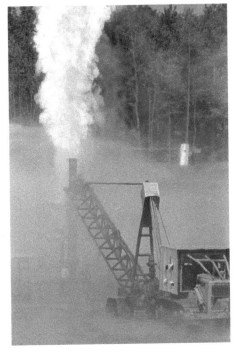

(Clockwise from above) Red Adair walked into the burning well pit to inspect the wellhead. He was covered with water spray to prevent burns.

A shielded tractor moved a new wellhead into place over the old well prior to closing a valve in the unit, which shut off the gas that fueled the fire. The flame was extinguished!

Red Adair talked about the new wellhead with workers prior to placing the unit over the existing wellhead.

11

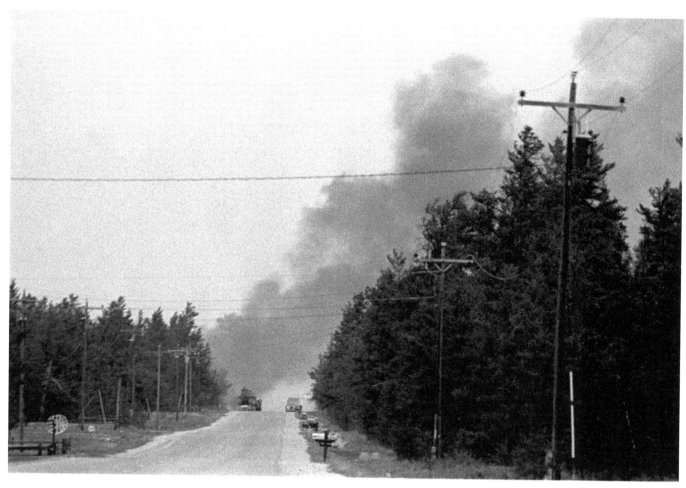

Grayling Forest Fire, 1990

It was a windy hot May afternoon when I decided to go fly-fishing on the Au Sable River east of Grayling. Driving along M-72 west of the town, I noticed heavy smoke. Fire trucks and DNR firefighting equipment were racing east to Stephan Bridge Road, right where I was headed.

The fire had broken out on Pappy's Trail and it was building fast. When I drove up to take photos, DNR personnel saw my T-shirt – "I fish, therefore I am" – and turned me away. So, I parked, put on a hard hat, protective eye wear and a yellow shirt, loaded up my camera gear, and returned to the command vehicle, again pleading for access. This time, I was allowed to travel – into hell. Homes were burning in the Pine Road subdivision and people raced out of there.

Throughout the night the fire raged, consuming more than 6,000 acres and destroying about 100 homes. Three hundred people were evacuated with no loss of life, thanks, in part, to the National Guard, activated by Governor Jim Blanchard to assist.

I processed film overnight, taking photos from a National Guard helicopter the next morning. The early on-site images ran extensively on the wire services.

(Above) A massive forest fire crossed Stephan Bridge Road heading northeast, destroying everything in its path.

12

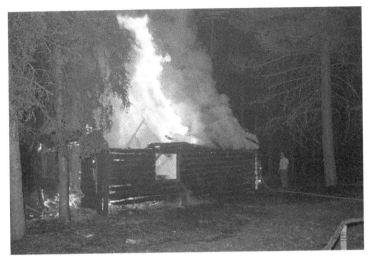

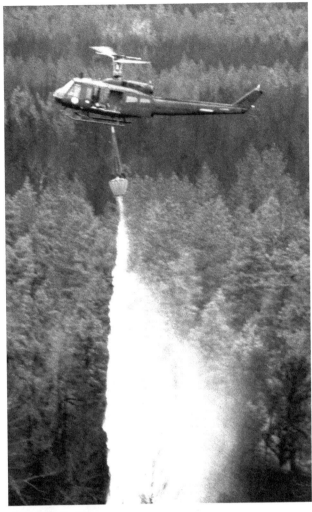

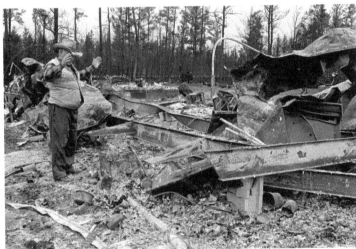

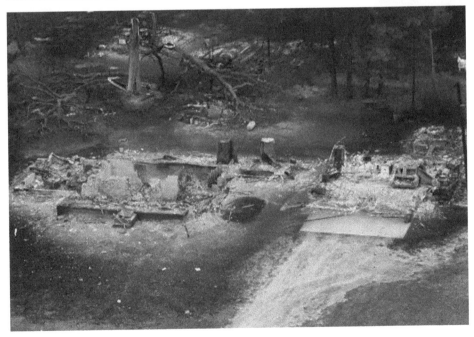

(Clockwise from top left)
A cabin burned as firefighters wait for water for their pumper. So many structures burned there was little that could be done to save them.

A Michigan National Guard helicopter dropped water on hot spots the morning after the fire had destroyed thousands of acres.

An aerial shot of the destruction.

John Murray viewed the remains of his retirement home and property.

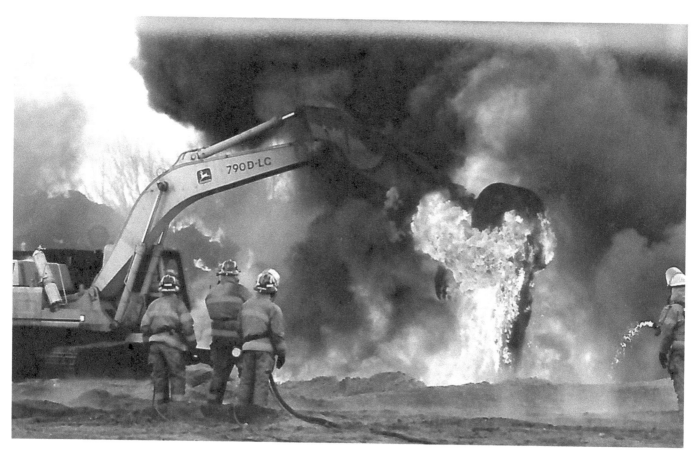

Grawn Tire Fire

On Dec. 29, 1995, the police scanner at the *Record Eagle* went nuts – a tire fire
had broken out at Carl's Retreading in Grawn. For weeks afterward, tens of thousands
of tires burned at temperatures of up to 2,500 degrees Fahrenheit. The Michigan National
Guard provided water cannons to chew into the massive piles of tires, and crews spent
days and nights into the new year battling the stubborn blaze. Neighborhoods were
evacuated to keep the toxic smoke from harming residents until it was safe to return
home. Toxins poisoned the area and neighbors, worried about the contaminated
water table, resorted to drinking bottled water.

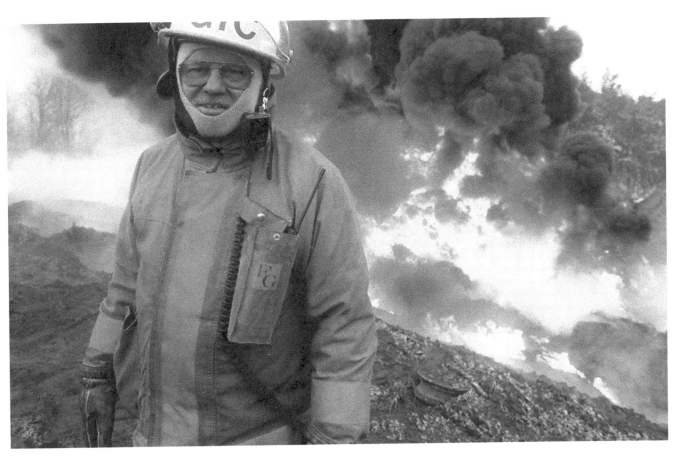

Fire Chief Fred Muller

Fred Muller was a fire chief with the Grand Traverse area and an active arson investigator with National Fire Academy in Maryland. While chief of the Grand Traverse Rural Fire Department in late 1995, a tire fire broke out in Grawn. Thousands of tires burned up to 2,500 degrees Fahrenheit, in a battle that lasted weeks.

Muller established a community response, rotating dozens of firefighters into the fire for short periods for safety and evacuating area homes. He also quickly created a check-in system with bar codes on individual name tags, which listed blood type, medical records and contact information for family. Each person was checked in on-site and checked out, ensuring everyone was accounted for. The system is still used in large emergency situations nationwide. Muller died in 2000 and is missed by all of us who knew him.

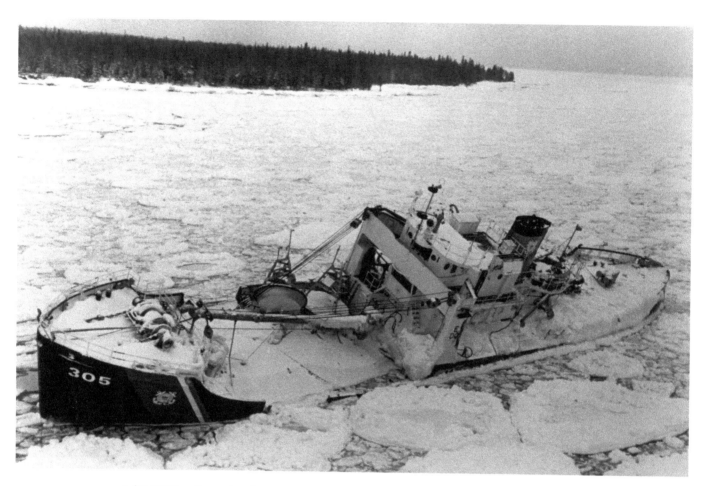

A $2 Million Buoy Tender Runs Aground

Navigation buoys are removed each fall by the U.S. Coast Guard for the winter months. But a navigation error stranded the 180-foot USCGC buoy tender *Mesquite* on a shoal in the early hours of December 4, 1989. A $2 million loss, the ship was scuttled and sunk in 1990 for use as a fishing reef and dive site.

For weeks, the floating shipwreck attracted lawless souvenir hunters, and the Coast Guard would periodically fly over the ship to warn them away. In mid-December, I hitched a ride on a Coast Guard helicopter to record the fate of the 47-year-old ship.

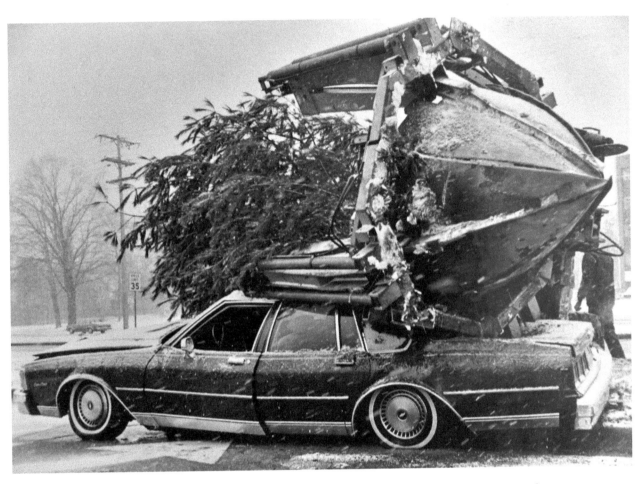

Tree Crusher

Duane Groesser's 1981 Chevrolet Caprice was crushed by a 15-foot pine tree that
was being transported on a tree-digging truck. The truck driver misjudged the turn onto
Grandview Parkway in December of 1986. Trying to make the turn at a high rate of speed,
he overturned the truck, and several tons of trees and machinery flattened the Chevy.
Miraculously, Duane wasn't hurt.

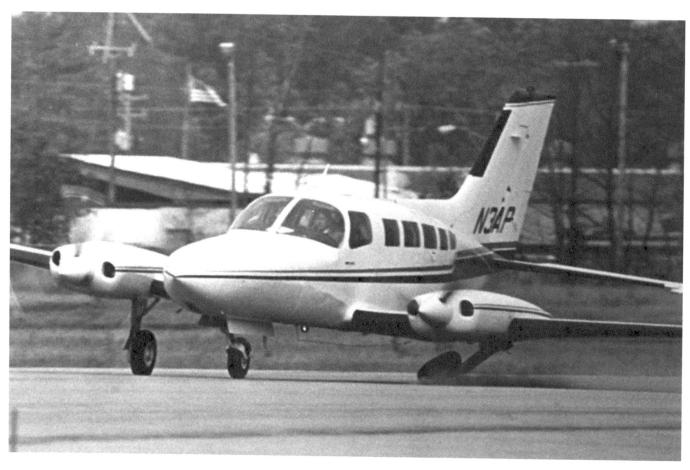

I Thought I Was Going to Die …

The call came over the police scanner that an aircraft emergency was unfolding at Cherry Capital Airport. The landing gear of a chartered aircraft would not lock up or down. The pilot then attempted to lock the nosewheel into place and make a touch-and-go landing. But the wheel under the left wing collapsed, dropping the left engine propeller into the concrete apron and forcing the plane spinning nearly out of control.

Early on, I decided to hitch a ride with a fire truck onto the tarmac to get a good shot, but now with the crippled airplane flying directly at us, I thought we were going to die. Thanks to a retired Navy pilot at the controls, I escaped the assignment unscathed – so did businessman Dick Templeton, who was on board the plane. At a photo seminar contest the following year, a judge threw the image out, saying it didn't look real. It was very real to all of us who watched this near-tragedy unfold.

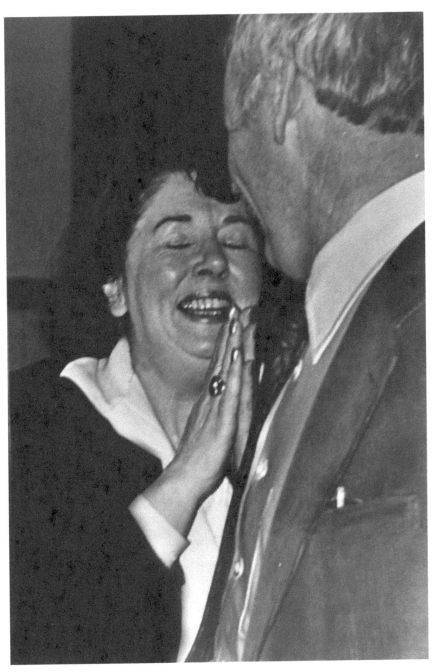

Not Guilty

Jeanette Smith of Kalkaska thanked attorney Dean Robb after she was found not guilty in
1979 of murdering her husband. The case – closely followed by national media – was one
of the first cases claiming spousal abuse as a defense. Dean was a devoted defender
of women. In fact, he was a lifelong advocate of many who had suffered legal injustice.
He was passionate and well-loved by all who knew him.

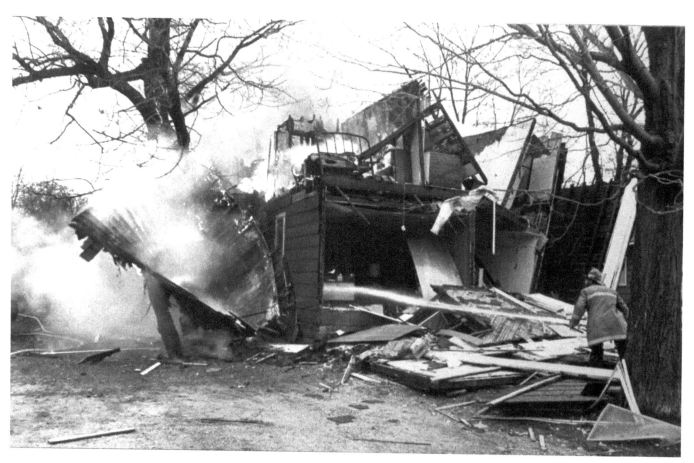

Webster House Explodes

My roommate woke me up at daybreak on Easter Sunday in the late 1980s – he had heard a scanner report of a house explosion. We raced to Webster Street, where we saw what remained of the two-story house. A gas leak had triggered the blast.

Unbelievably, a couple and their baby downstairs were uninjured. A man living upstairs also escaped injury, but the hands of his alarm clock, hanging off the floor joist, were forever stopped, marking the time of the explosion.

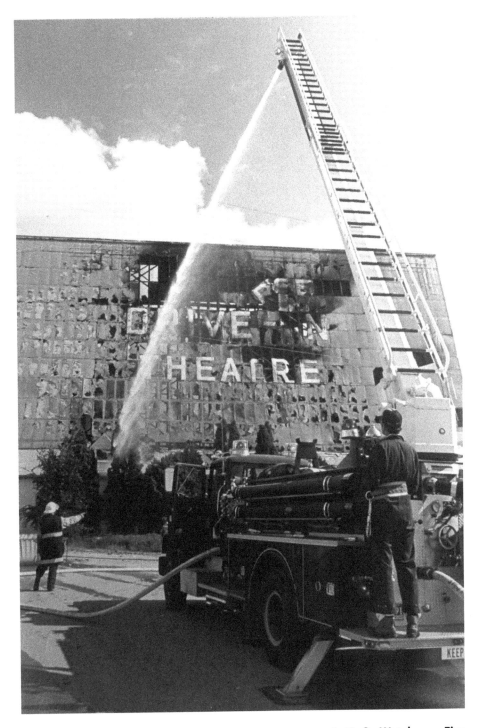

Let's Go Watch ... a Fire

It was a sunny, warm Saturday in late September of 1981. I had settled in to watch a college football game when the scanner sounded off. The Traverse Drive-In Theatre in Acme was burning up.

I quickly arrived to take photos, sad to see the drive-in aflame, knowing that thousands in the region, including myself, had watched movies there for decades. Investigators immediately suspected arson. The drive-in had been closed for several years, and the wooden movie screen had no power.

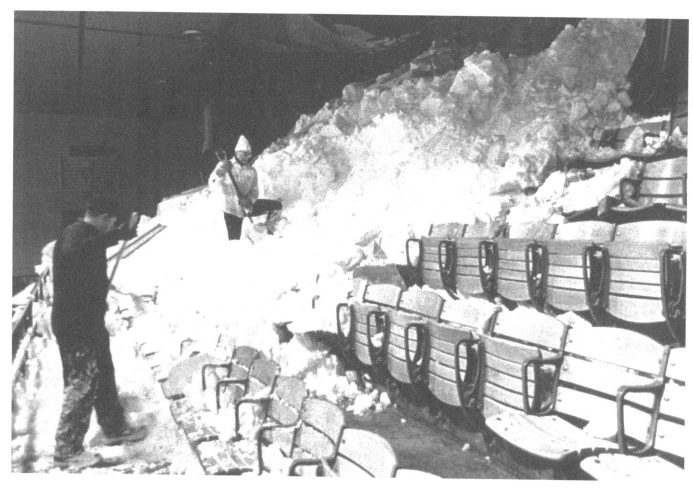

Today's Work-Out: Shoveling out a Gym

I received a call from *Record-Eagle* editor Jim Herman who heard about a possible roof collapse at the nearby high school from his son in February 1995. Classes and a scheduled basketball game had already been called off due to a snowstorm so the gym was fortunately empty, and no one was hurt.

A portion of the south roof over the spectator-seating section had caved in, dropping tons of snow onto the gym floor. Traverse City Central High School Athletic Director Dave Dye, center, helped remove tons of snow from the bleachers at the school gymnasium, shoveling it down to the floor where a tractor removed mound-after-mound of the white stuff.

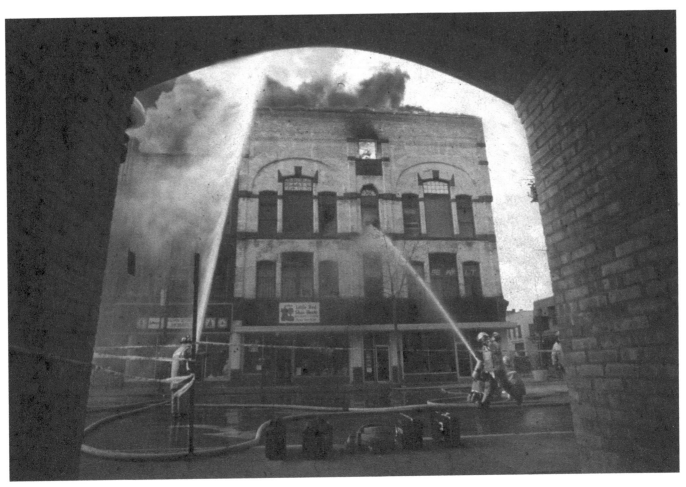

Fire Damages the Masonic Temple

Sirens were activated at daybreak across the city on April 28, 1987, alerting me through my open bedroom window on Traverse City's west side. I could see heavy smoke and raced downtown. On the way, I heard on my car's police scanner that the Masonic Building on Front and Union was on fire. The 100-year-old brick and stone building was heavily damaged but has since been rebuilt.

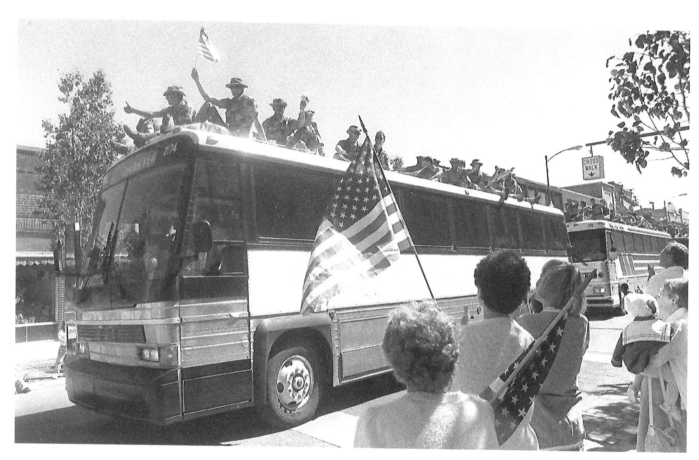

Flags of Affection!

When I learned the troops from the 182nd Transportation Company were returning home from Operation Desert Storm in May of 1991, I drove north to meet up with the convoy. The troops were riding in two buses, and I caught up with them south of Charlevoix. The news was broadcast to alert area residents of their arrival times so they could line the streets to welcome them home. It was an impromptu parade from Acme through downtown, the troops climbing onto the bus roofs to wave and applaud the crowds. A hugely deserved welcome home.

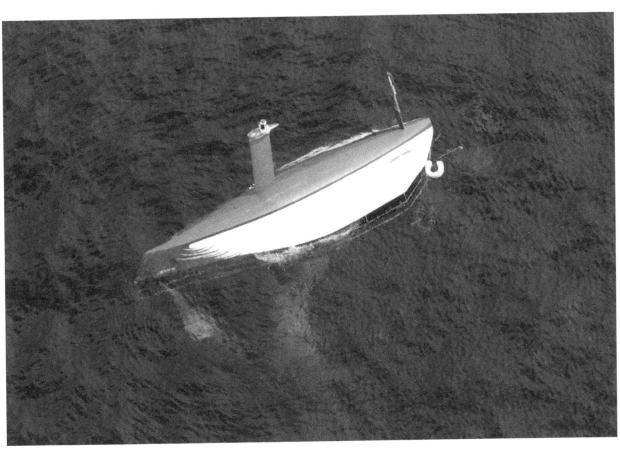

Tragedy Strikes the Chicago-to-Mackinac Sailboat Race

The news came over the radio in the early morning: Two people were missing and presumed lost in a ferocious storm on Lake Michigan. The 35-foot sloop *Wing Nuts* had flipped upside down on Lake Michigan south of Beaver Island early Monday, July 18, 2011, in the annual Chicago-to-Mackinac Sailboat Race.

The Coast Guard launched a helicopter and invited me to fly with them to the scene, realizing this was a major story. The race is the oldest and longest freshwater sailboat race in the world, and no one had ever perished in the event until that morning. Six crew were rescued by other sailboats nearby, but the bodies of a man and woman were recovered the next morning at daybreak. This image was picked up and published in Yugoslavia, England and other countries.

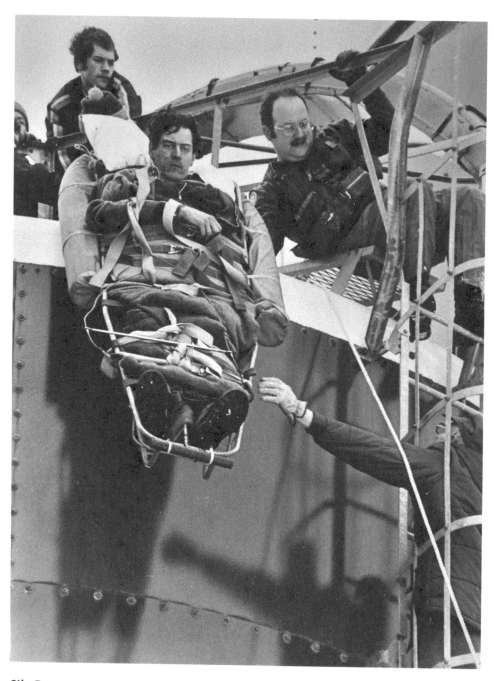

Silo Rescue

In the winter of 1981, a call on the newsroom scanner dispatched a U.S. Coast Guard helicopter to a farm accident near Cedar. Floyd Young, 35, was working to pry open a silo hatch and was overcome by fumes from the organic silage stored in the structure. Half-crazy from the poison, he was sedated by a Coast Guard medic and strapped to a backboard, lowered to the ground and flown to Munson Medical Center via a waiting helicopter in a snowstorm. He survived and approached me years later to let me know he was fine.

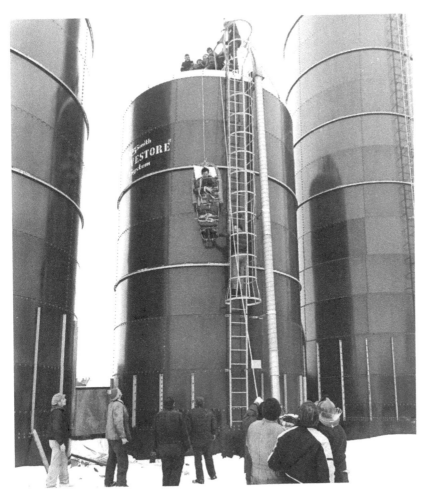

(Left) A drugged Floyd Young was dropped over the edge of a silo.

(Below) Rescue personnel and Coast Guardsmen carried Young to a waiting U.S. Coast Guard helicopter for a short flight to the hospital, where he recovered from the incident.

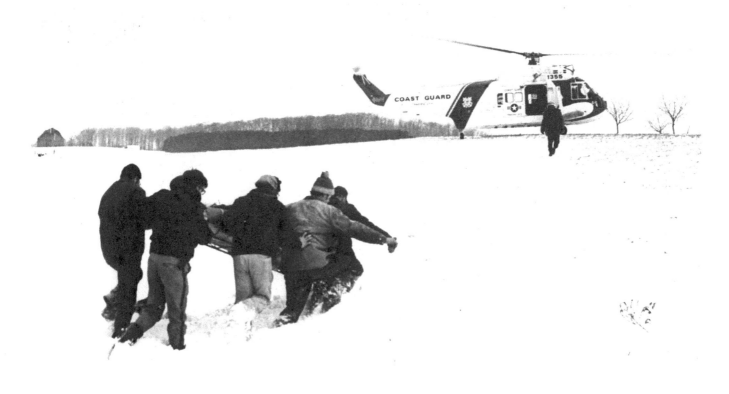

FEATURES: THE LIFEBLOOD OF A DAILY NEWSPAPER

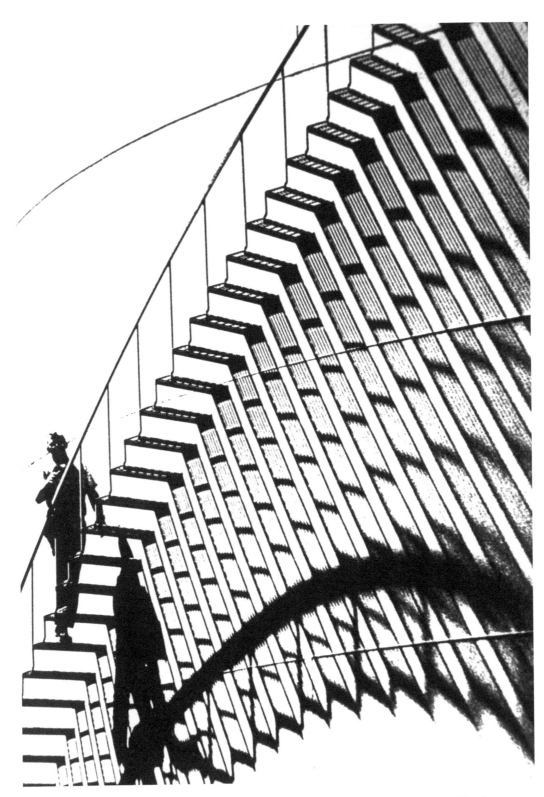

Terminal Shadow

I used to admire the long shadows on the oil tanks in Greilickville on sunny days and waited until the summer solstice arrived to capture this photo of Harold Thomas, manager of the oil terminal. As long as I had a sunny day, I could count on the longest shadows of the year. It was well worth the wait.

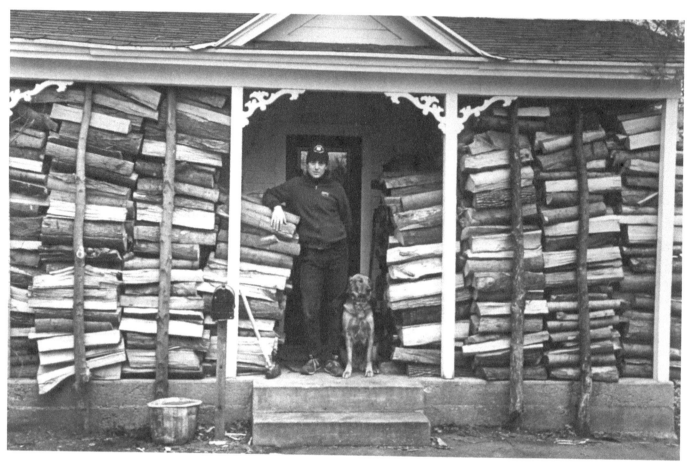

Ready for Winter

I spotted this pile of wood on a porch on Washington Street, one of Traverse City's elegant residential neighborhoods.

Skip Van Horn and his dog, Steamer, had cut and stacked the logs in preparation for the upcoming winter.

"Eight cords for the wood-burning stove should last the winter," he proudly told me.
I captured him relaxing after he ended his task. That woodpile would warm him up twice.

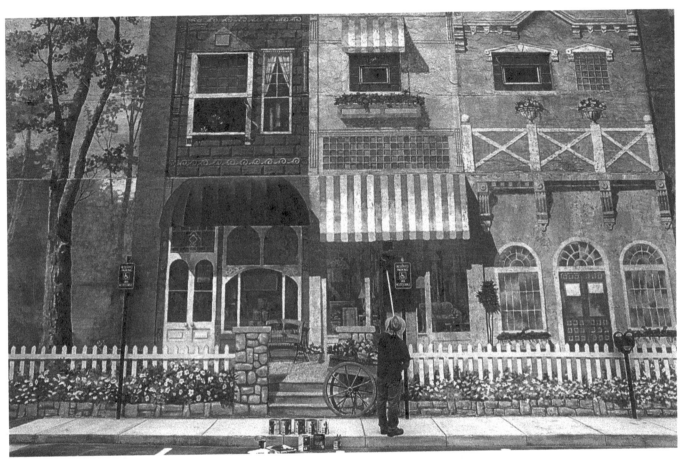

So Real, You'll Want to Feed the Meter

A large exterior wall of a Petoskey business was used as an 80-foot canvas in July 2001
by Grayling artist Terry Dickinson, who painstakingly created a scene of downtown storefronts.
At first glance, it fooled a lot of pedestrians passing by.

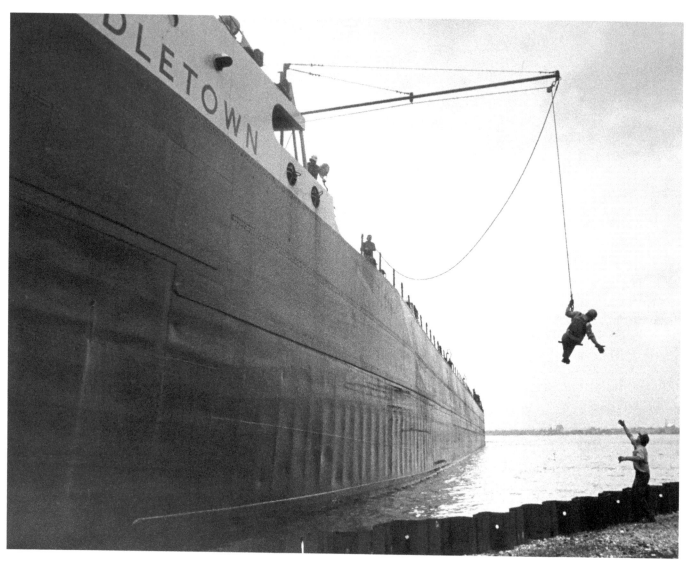

Could You Give Me a Hand?

For decades the fuel terminals on the shoreline of West Grand Traverse Bay were busy with deliveries. I was always watching for activity and good images. This 1982 photo shows a crewman from the *Middletown* being lowered to the Greilickville coal dock so he could catch a line and secure the ship to the pier. His job was to off-load coal with an onboard conveyor system.

The vessel had a long and productive career, serving in WWII as an oiler for the U.S. Navy. It was bombed by a Japanese plane and subsequently suffered several more collisions. It was rebuilt into a 730-foot bulk carrier powered by 7,700-horsepower, steam turbines. *Middletown* could travel at 16 mph under a full load, one of the fastest vessels on the Great Lakes. She was decommissioned and scrapped in 2018.

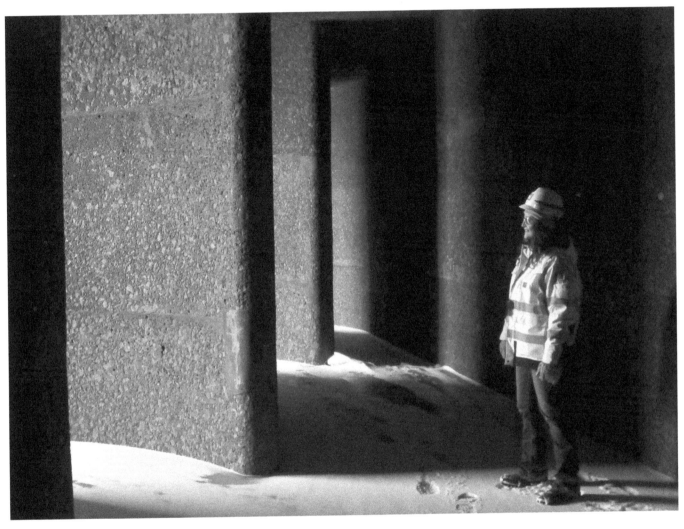

Hidden Water Work

Thinking it would make a good photo, U.S. Corps of Engineer's Chief of Maintenance LeighAnn Ryckaghen took me to the water channel at the bottom side of the Poe Locks on March 12, 2019. A total of four tunnels allow water to move in and out of the huge locks as ships are raised or lowered in Sault Ste. Marie. You ought to see how smooth those walls are.

The Soo Locks in Sault Ste. Marie are drained for 10 weeks each winter for maintenance. It's a huge project and the locks, when empty, are impressive. A couple of years ago, I wrote a story for the *Detroit News* about the work.

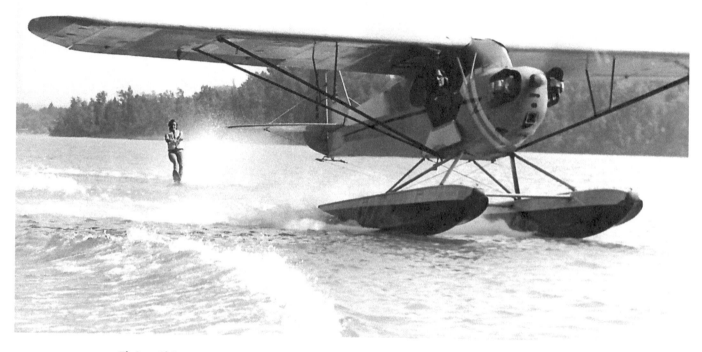

Flying Skier

Nancy Loveland was well-known as a TV news personality, but she is also a hugely talented water skier. Her father owned a 1946 Piper Cub built on floats, a great airplane that you wouldn't think could actually take off. Pilot Roland Schultz liked challenges so he contacted me about Loveland skiing behind the Cub. I jumped at the chance to photograph the event in late July of 1980. I raced around Cedar Lake in a boat at a harrowing 50 mph to get the shot. She made the stunt look easy, and the photograph was an instant hit with readers of the *Record-Eagle*.

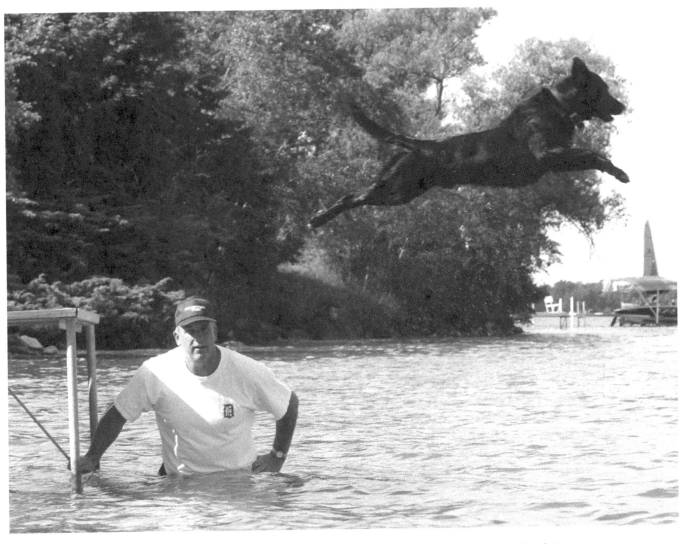

Dock Dog

Former Detroit Tigers pitcher Milt Wilcox rescued a dog and named him Sparky. It turned out he had a great talent for jumping off docks. I met Wilcox and Sparky in 2003 on Torch Lake while on assignment for the *Detroit Free Press* and captured Sparky doing what he did best – jumping for distance. It was still early in the sport of dock-jumping dogs, and the media ate it up. Wilcox and his family now bring the traveling Air Dog Show each year to the National Cherry Festival. It is a fun event full of happy dogs and delighted fans.

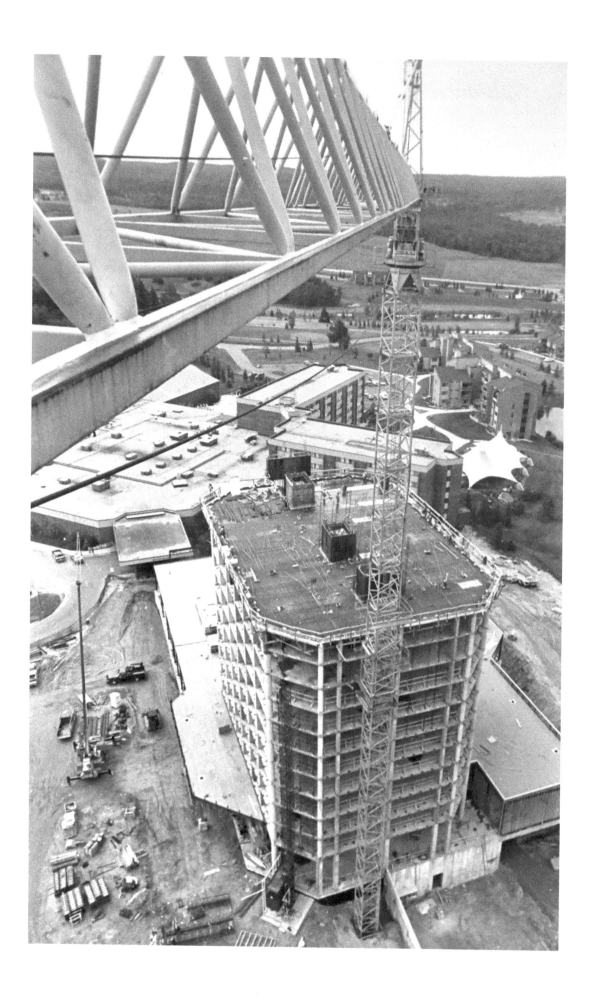

Over the Edge

When the Grand Traverse Resort Tower was being constructed in 1985, a sky crane was erected to build the structure, a first for northern Michigan. I planned to do a photo page on the crane and its operator, an engineer from Manton. I had previously asked if I could put a camera out on the end of the crane and was told there was no problem.

After climbing to the top, the engineer handed me a safety harness. I was a little puzzled.

"The seat out there is all yours," he told me, meaning I was supposed to boldly venture out to the end of the crane. I was game so there I was, dangling high in the air with camera in hand. The picture was worth it, but solid ground felt really good at the end of the shoot.

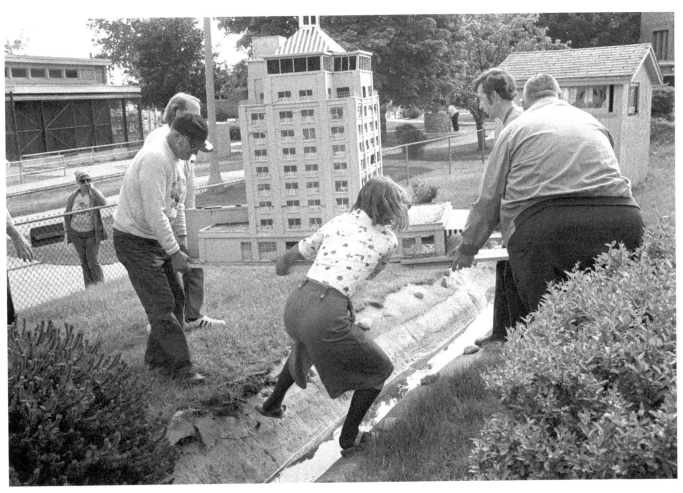

Traverse City Gets Small

During the Great Depression, men with the Civilian Conservation Corps built a miniature scale model of Traverse City. Each spring, volunteers set out the miniature city at the Clinch Park Zoo, lovingly placing the tiny buildings where they belonged along the concrete streets. At the time in late May of 1977, I worked for the city Parks Department and cut the grass of the city's tiny yards. The buildings are now in storage, awaiting someone to find them a home.

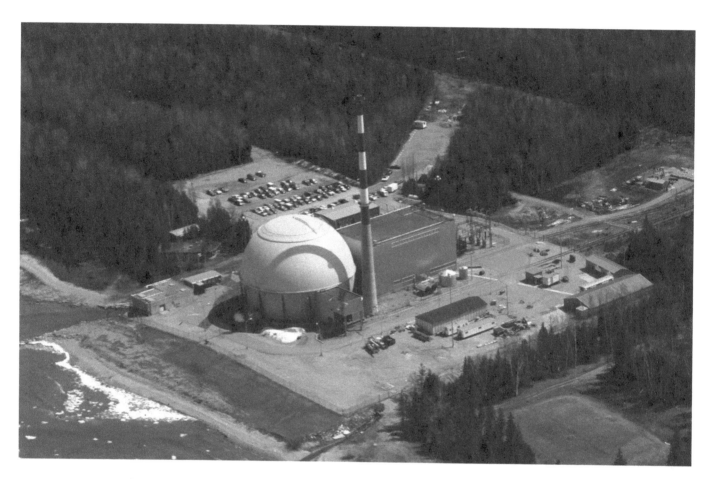

The Big Rock Story

Construction of the Big Rock nuclear power plant began in 1960 near a landmark boulder on the Lake Michigan shoreline. Located north of Charlevoix along Lake Michigan, the $27.7 million plant was the first nuclear plant in Michigan and the fifth in the U.S.

Commissioned in 1963 by the Consumers Power Company, the boiling water reactor produced 67 megawatts of electricity. One single 10-ton load of uranium could generate the same amount of electricity as 260,000 tons of coal.

Our family made many trips north to watch its construction.

(Above) An aerial image of the operating plant shows its proximity to the shore and the size of the facility.

The containment dome could easily be seen and photographed from a roadside park east of the plant.

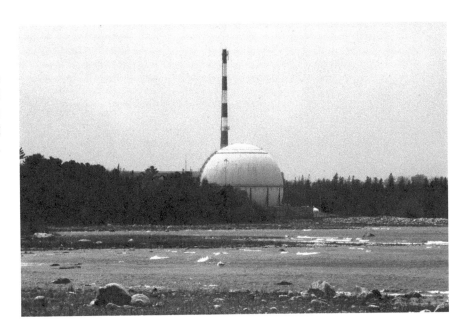

The five-foot steel walls of the containment dome were slowly removed over several months.

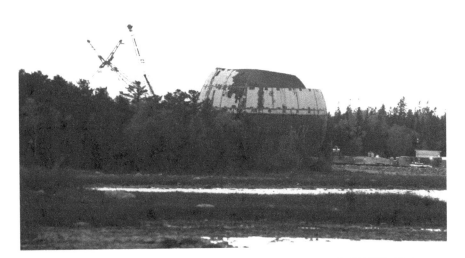

The nuclear plant's concrete reactor cavity was removed in 2004.

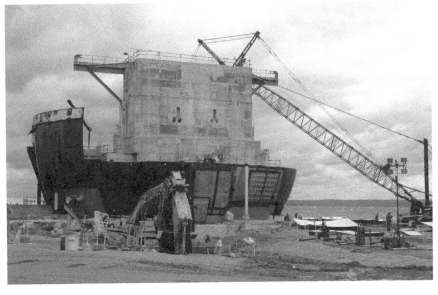

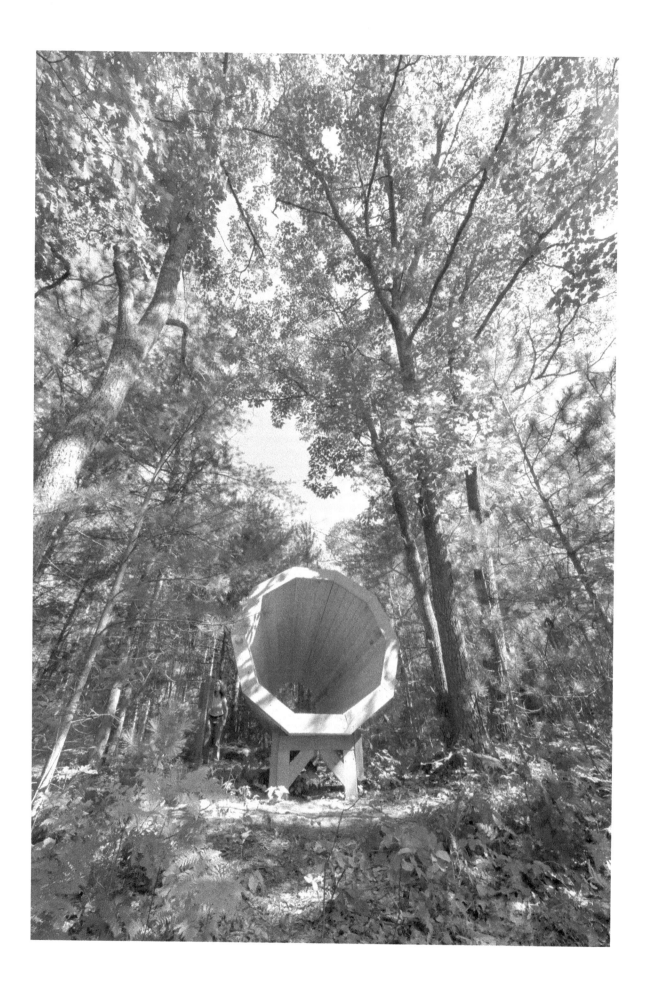

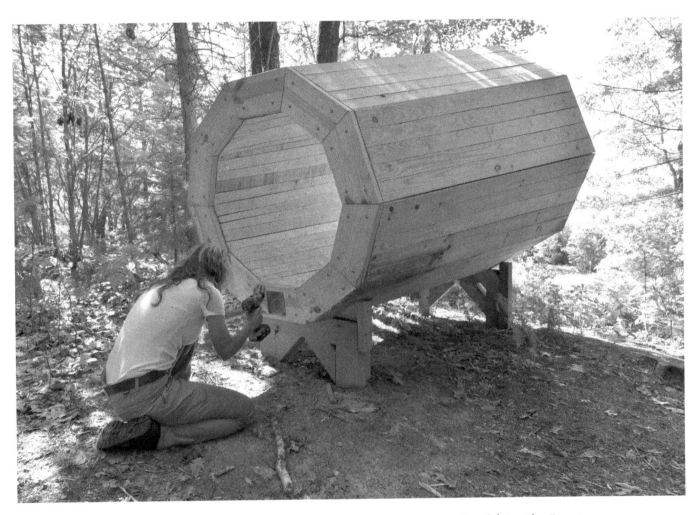

Amplifying the Forest

Anne Fleming, Director of Communications for the Little Traverse Conservancy sits
in a huge wood megaphone in the Boyd B. Barnwell Family Preserve near
Afton, Michigan. Monday, July 22, 2019.

The 10-foot wood structure was built by the Petoskey High School shop class with donated
materials. The megaphone amplifies the sounds of the surrounding forest and allows visitors
to sit, relax and enjoy the unique device, believed to be the only one in the United States.

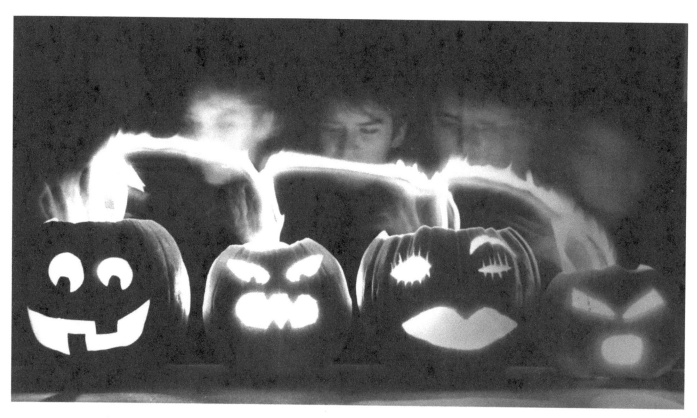

Scary Pumpkins

Playing with light in October 1985, I photographed Interlochen Arts Academy student Michelle McKerchie in a single photo frame lighting four pumpkins as the match moved from one to the next. People thought this was trick photography, and it was in a manner of speaking. I left the shutter open while making a 30-second exposure.

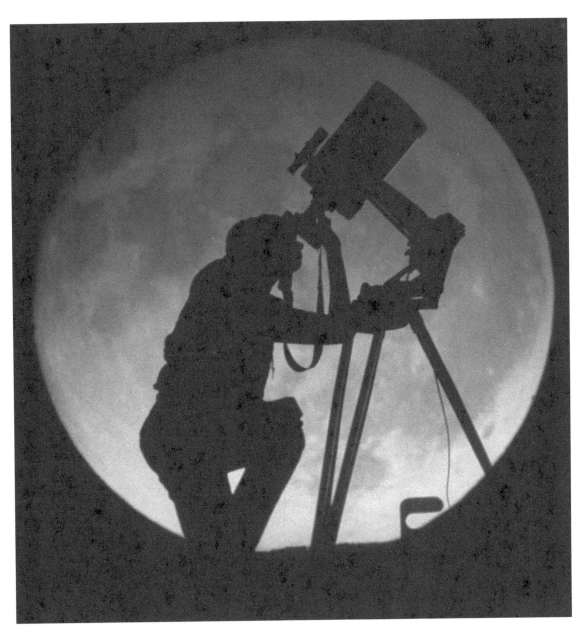

Harvest Moon

I captured this photo of Eric Sherberneau, a photo intern at the *Traverse City Record-Eagle*, watching the harvest moon rise over the Joseph Rogers Observatory at Northwestern Michigan College. This was before digital photography, and Photoshop using a double exposure was fun to try. Sherberneau became a Chicago-based pilot with United Airlines.

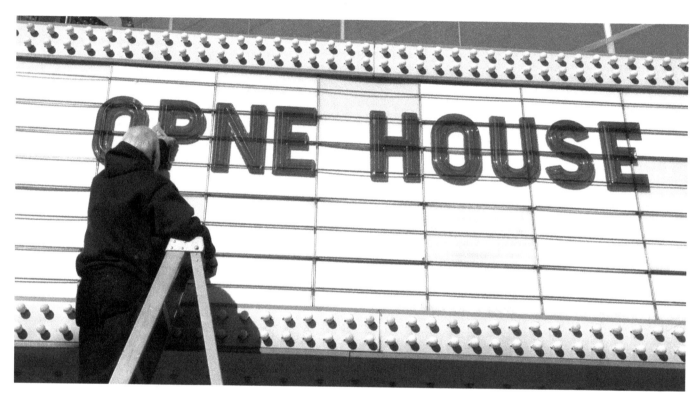

"Opne House"

In 2007, I watched as dozens of workers and volunteers invested their time and energy renovating the State Theatre in Traverse City. Later that year, after a community-wide effort to save the iconic theatre, their work was complete and it was ready to reopen. Changing the marquee sign to advertise the open house, a volunteer made a brief mistake in spelling. The typo by the admittedly exhausted worker was so telling of this one-last push, we just had to publish the image.

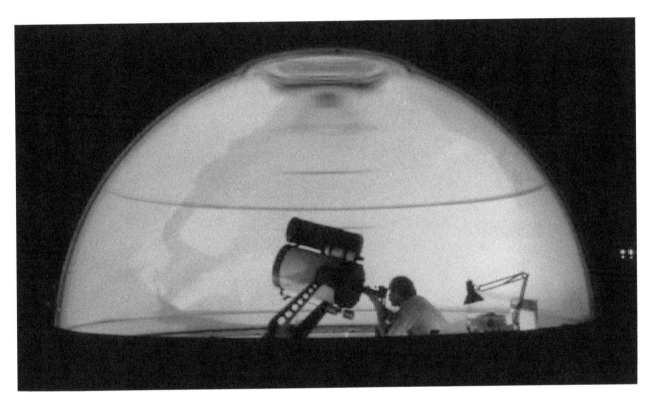

Vanishing Dome

Working with the Rogers Observatory at the local college I had an idea: set a camera
on the roof and rotate the dome and see what happens. Shooting in black-and-white,
the image came out better than I anticipated. It was published in the Griffith Observatory
monthly newsletter in 2005 and made the Associated Press wire.

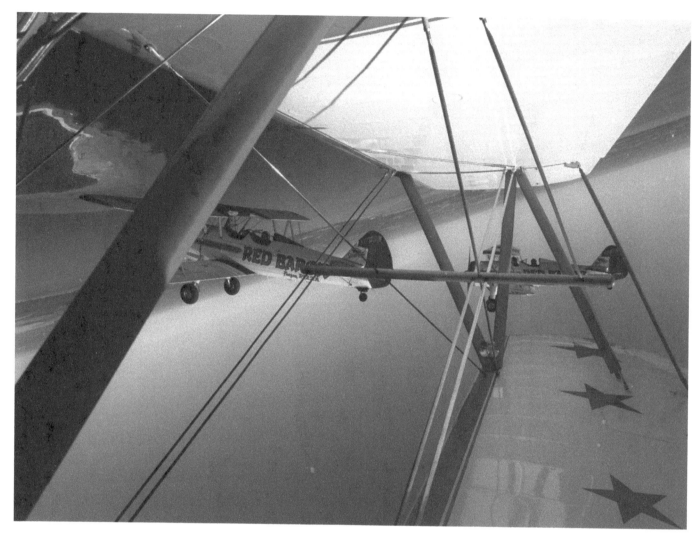

Flying Upside Down

If I could grow wings and fly, I would be a happy man. The second best is to be in the cockpit
of all sorts of aircraft. In 2003, the Red Baron Pizza Squadron visited the National Cherry
Festival and offered me a chance to fly formations as a passenger in a restored biplane.
Yes, we're talking flying upside down over West Grand Traverse Bay. What a thrill!
A fellow photographer thought the photo was printed wrong since it was upside down.
When I explained that the placement was correct, she turned pale.

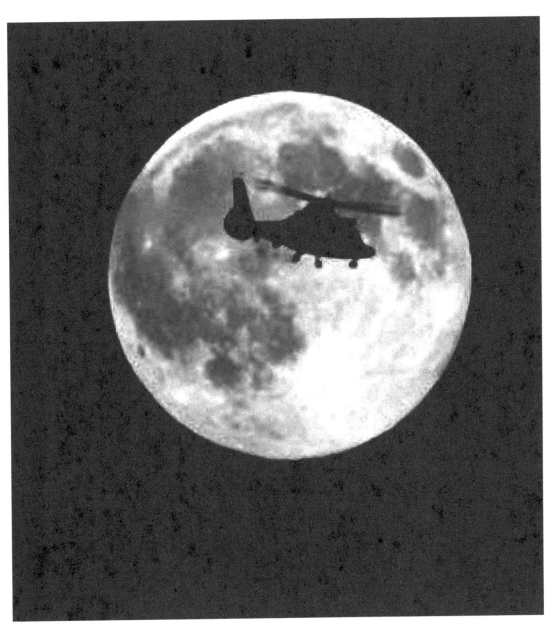

Helicopter Moon

While waiting for a chartered single-engine airplane to fly me over the renovated Thirlby Field
for the Trojans-Titans football game, I noticed the full Hunter's Moon rising in the east.
A U.S. Coast Guard helicopter was traveling in circles awaiting a flight over the field
at the end the national anthem. I willed it to fly in front of the moon. The third time around
was the charm and this October 2010 image was fantastic. I knew it was a once-in-a-lifetime
shot. It ran on the Associated Press wire, and let's just say the Coast Guard was
over-the-moon with all the publicity.

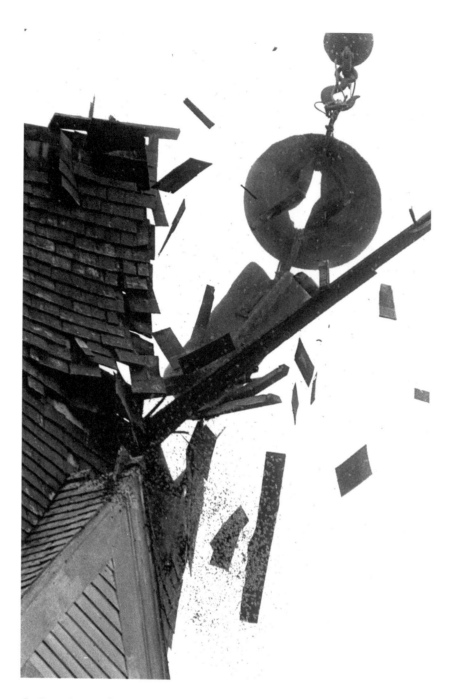

St. Francis – Making Way for the New

The corner of Cass and 10th streets in Traverse City was the home of the St. Francis of Assisi Catholic Church for 90 years. Aging and too expensive to repair, the church was removed in 1977.

I was interested in the history of the facility and gathered to witness the removal in June 1977.

Upon first contact with the wrecking ball, a massive black cloud emerged from the steeple. Bees. Thousands of them. I ducked into my nearby car, escaping without a sting. A beekeeper reportedly removed the queen, and the rest of the beloved landmark was removed over the next week. The new church stands on Union and 13th Street, the original bells mounted on a campanile.

(Facing page) Thousands of bees left
the steeple as the first punch from
the wrecking ball collapsed part
of the 90-year-old structure.

(Clockwise from top left) With windows,
doors and all interior removed,
pedestrians stopped to view the last
days of the church building.

A crew from Elmer's carefully removed
the bells, one at a time.

Sister Mary Ann Catherine and Sister
Mary Edith got their first close-up look
at the bells.

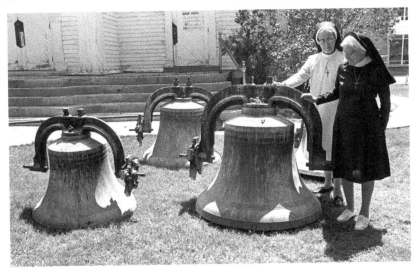

PEOPLE WHO TOUCHED OUR LIVES

Count Zappula

Don Melvoin, with his warped sense of humor and love of children, gained fame locally.
He was a much-loved local television character and a good friend, too. At the height of
his popularity, he created two campy characters – Deputy Don and Count Zappula –
which were turned into TV shows by the same name on the local NBC station.
Area residents were so convinced he was a cowboy they called upon Deputy Don
to lasso a white-tailed deer on Oak Street and remove the animal to safer environs.
Melvoin arrived and the deer ran off, un-lassoed.

The Voice of Northern Michigan

Merlin Dumbrille was the voice of northern Michigan. Anyone lucky enough to live in northern Michigan most likely heard his smooth and comforting voice on radio or television.

Dumbrille began his first job at WTCM in 1951 at the age of 17. For 58 years, his avid fans listened to his reports on "Farm and Orchard Time." He also worked as a weatherman on WPBN television, and he announced the National Cherry Festival from the roof of the WTCM radio studio on Front Street for 46 years. He served on numerous community boards and volunteered throughout his life. He was a kind and gentle family man and deeply loved by the community. This photo was taken in 2008, six years before he died at the age of 81.

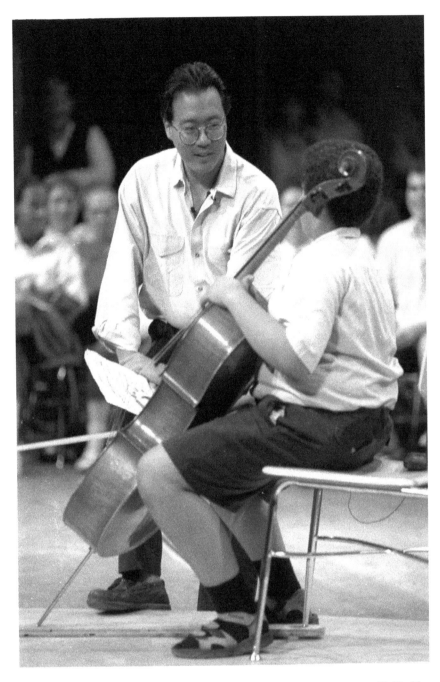

Yo-Yo Ma

Storms had taken down a monarch white pine tree near the Interlochen Music Camp in 1994. A cello was made from the downed tree, over 100 years old.

The school invited internationally renowned cellist Yo-Yo Ma to be the first to play this unique and wonderful instrument in 1995. He agreed and also held master classes for cello students, selecting several to work one-on-one with him on a special piece. Jared Snyder, 12, of Elm Grove, Illinois, played for the artist, who gently instructed him on the finer points of the composition. I was intrigued by Yo-Yo Ma and his loving response to students and music. He came over and introduced himself to me; I was touched by his generosity.

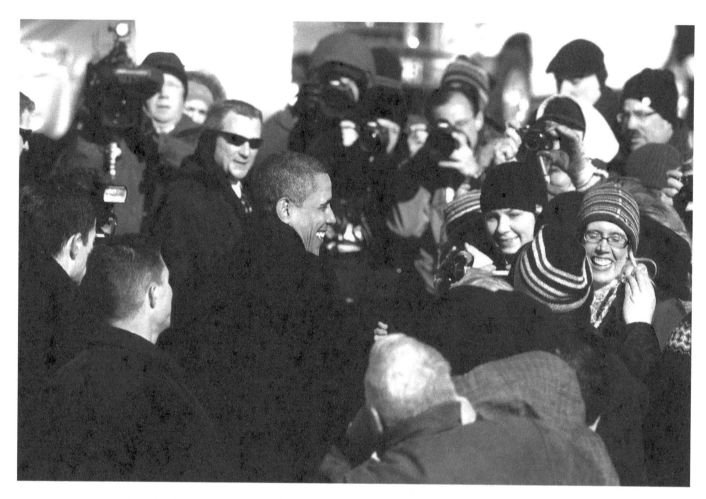

President Obama Goes North

I traveled to Marquette in February 2011 to work with Associated Press Michigan photo
editor Carlos Osorio to photograph President Barack Obama. In sub-zero temperatures, the
President greeted local dignitaries and guests at Sawyer International Airport
before heading to the Superior Dome at Northern Michigan University,
the largest wood structure in the world.

The President also spoke about the necessity and progress of a new wireless program
in the Upper Peninsula that would deliver the Internet to some of the outlying, rural areas.

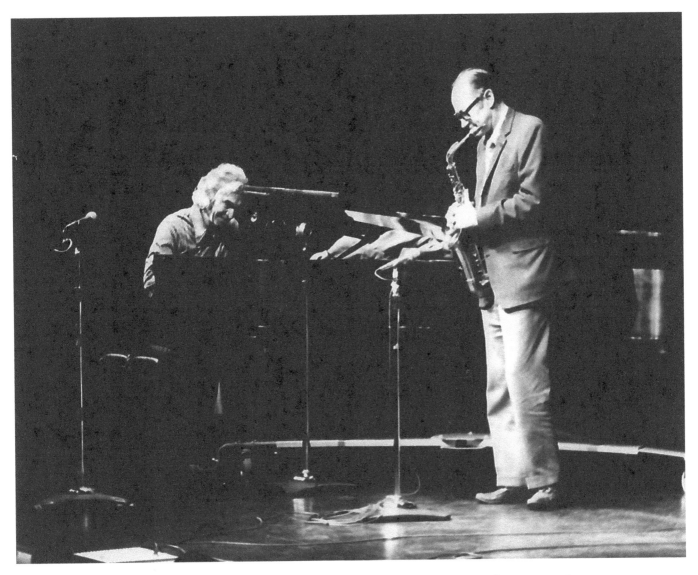

Dave Brubeck and My Backstage Faux Pas

Jazz came to Interlochen Arts Academy in 1976 when jazz great Dave Brubeck stopped by on his 25th anniversary tour. I love jazz and took advantage of my photographer status to get back stage. Standing offstage, a rumpled man in a blue suit stood beside me. I mentioned to him that I couldn't wait to hear Paul Desmond, the alto saxophone artist who wrote "Take Five," an award-winning piece and one of my favorites. We chatted, then he was called on stage. Yep, it was Paul Desmond. He flashed a wink at me as I stood red-faced in the wings. The tune never sounded better.

Desmond suffered a medical emergency shortly after the concert and never played again. I'm grateful I saw his last show.

Gordon Lightfoot Honors Sailors

Sailor and songwriter Gordon Lightfoot established a $10,000 scholarship in 1976 at a concert in Traverse City exactly one year after the steamship *Edmund Fitzgerald* sank to the bottom of Lake Superior. Great Lakes Maritime Academy cadet David Weiss, 22, and former cadet Thomas Bentsen, 23, perished when the SS *Edmund Fitzgerald* disappeared in 1975.

Lightfoot has since continued to donate to the scholarship fund and was named an NMC Fellow in 1989, recognized for his financial contributions that have assisted dozens of students. Lightfoot himself often sails Lake Huron, passing by the Fitz. His love for the lakes and its dangerous storms is immortalized forever in "The Wreck of the Edmund Fitzgerald." I met band members Thunderbird and Pee Wee after the concert, drinking beer and playing the video game "Tank." I was also able to meet and talk sailing and guitars with Lightfoot, who plays a 12-string Gibson.

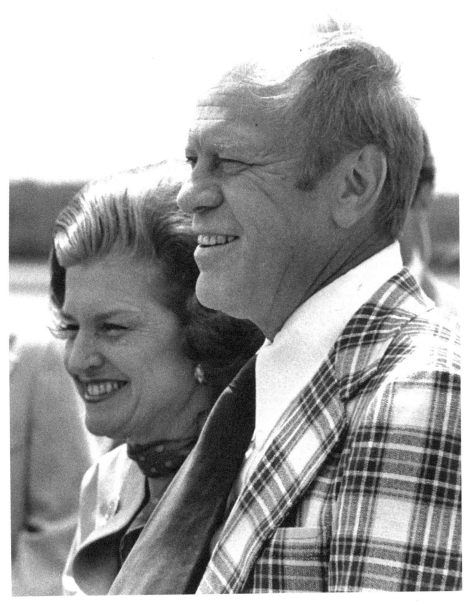

My First Presidential Photo Shoot

The *Grand Rapids Press* contacted me in July 1975, assigning me to capture photos of National Cherry Festival guests President Gerald R. Ford and Betty Ford. "Okay," I thought, "this could be fun."

I started taking photos with the rest of the press at the airport, then followed the Fords down the parade route of Front and Union streets. Afterward, I went out to U.S. Senator Bob Griffin's Long Lake home in the afternoon in a 35-car caravan. On the way, we were met by at least a dozen cows blocking North Long Lake Road, who normally reside at Gallagher's Farm. How they came to gather in the road is a whole 'nother story. Governor Milliken introduced me to President Ford, who amazingly remembered me when I bumped into him at the Park Place Hotel several years later.

I knew that once I sent the film to the *Grand Rapids Press*, I'd never see it again. So, I took care to photograph the presidential couple using two cameras; I kept one roll of film as a memento of photographing my first president – and I still have it.

Stacy's Restaurant

Chuck and Julie Stathakis came to Traverse City in 1957, moving into a small house across from us in the Central Neighborhood. They opened a restaurant in downtown Traverse City named Stacy's, Chuck's nickname. The eatery became a popular gathering place for politicians, city leaders, visitors and the homeless. Julie liked nothing better than harassing the big shots, whether the governor or head of the Chamber of Commerce.

Julie's mission over their 30 years at the diner was to always show generosity and kindness and to never turn away a hungry person. With her heavy Greek accent, she called everyone "Slim" or "Fatso," and often added a scoop of ice cream without being asked.

Everyone cashed themselves out on an ancient National cash register, and the honor system worked for years. She once told me that she often ended up with more money than she charged at the end of the day because some people overpaid either out of generosity or unable to figure out the change. When she retired, she bought a big brick house on Wadsworth and Sixth streets to provide a halfway house for the down-and-out. That's what kind of person she was.

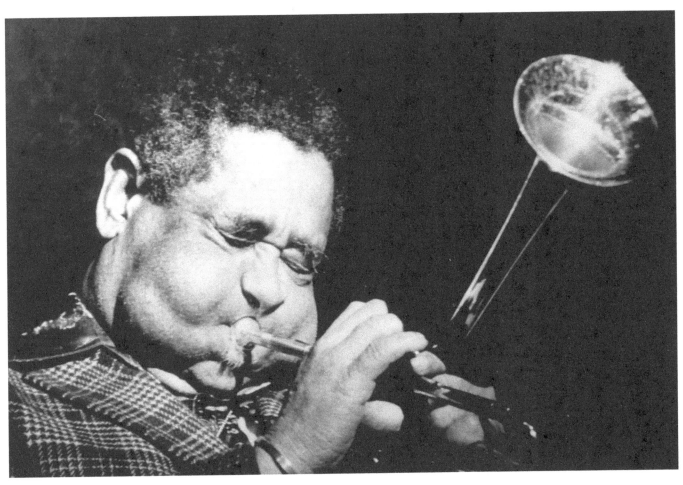

Dizzy

In March 1980, jazz trumpeter Dizzy Gillespie performed at Interlochen where his expressive horn playing was put on display. He visited several times and we became friends. After the concerts, we'd talk jazz and he'd share his tales of traveling with his horn. To this day, I have a signed photograph of Dizzy with his straight-up horn hanging in my office.

Two Governors Lend a Hand

Alaska Governor Sarah Palin and Michigan Governor Jennifer Granholm joined forces to measure siding for a Habitat for Humanity house. They put it on the house, too! The National Governor's Conference was being held in Traverse City in 2007, and many governors pitched in to build the home for a lucky family.

I was well-acquainted with Governor Granholm and met Governor Palin for the first time during this event. Judging by her obvious talent with a hammer, she had wielded one before.

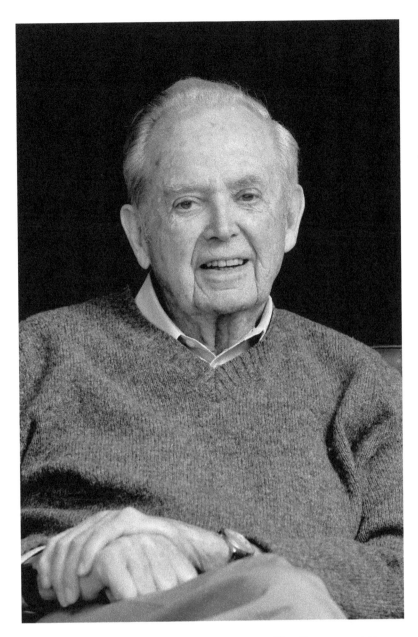

The Governor at Home

Growing up in Traverse City, everyone knew or had contacts with the Milliken family. Some shopped at the now-closed Milliken's department store or dressed up to dine at the second-floor Tea Room. Others knew the Millikens through their volunteer and public service work.

My father was Governor Bill Milliken's store accountant, and our family grew up with his children. My twin sister, Margaret, was a close friend with the late Elaine Milliken, his daughter who died of breast cancer. During his term as Michigan's longest-serving governor, I captured many different images: at the Labor Day Bridge Walk; cross-country skiing at the Old Mission Lighthouse with his wife, Helen; and jogging at the Civic Center. I took a photo for their Christmas card at the mansion on Mackinac Island and shared time at the Republican National Convention in 1980, where he introduced me to Ronald Reagan.

In 2014, I photographed the governor at his home where he invited me to lunch, and we spent five hours talking about his life. He was a kind and thoughtful man, and the world is a little less with his passing.

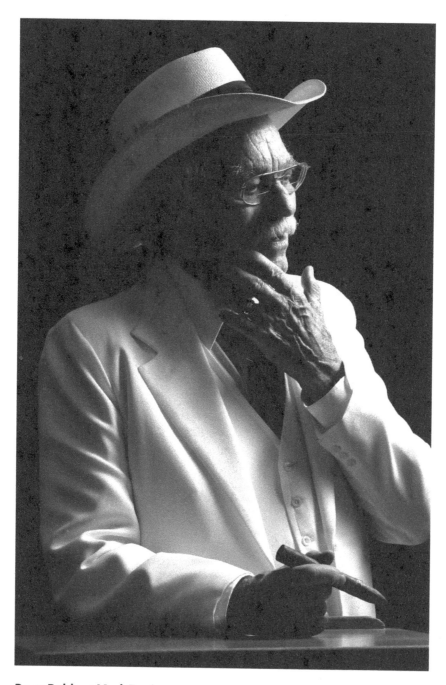

Dean Robb as Mark Twain

To know Dean Robb was to know a man with a passion for life, whether defending
a battered wife in court or marching for civil rights in the 1960s. He had a lighter side,
too – fly-fishing on the Au Sable River and spending time with his family.
Dean loved people, the law and justice. I captured him in this 2014 portrait in Elk Rapids
where he enthralled his audience with quips and stories from another time as Mark Twain.
He loved life as much as we loved him.

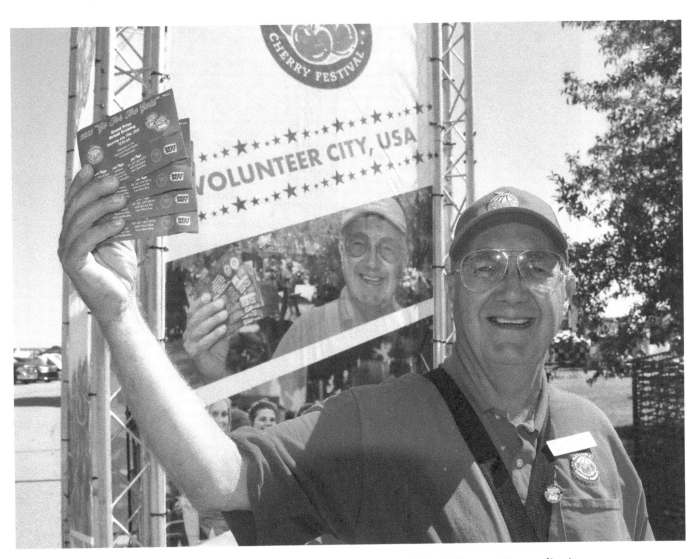

Peter Garthe, Cherry Festival Pin Salesman Extraordinaire

Peter Joe Garthe is a Traverse City icon. Known for years as a scorekeeper at high school sporting events, Peter also peddles National Cherry Festival pins to raise money for the festival each year. In 2021, when I took this picture, he told me that he'd sold more than 700,000 pins. He was also named as a grand marshal of a National Cherry Festival parade. Peter has been a friend for years and is loved by everyone!

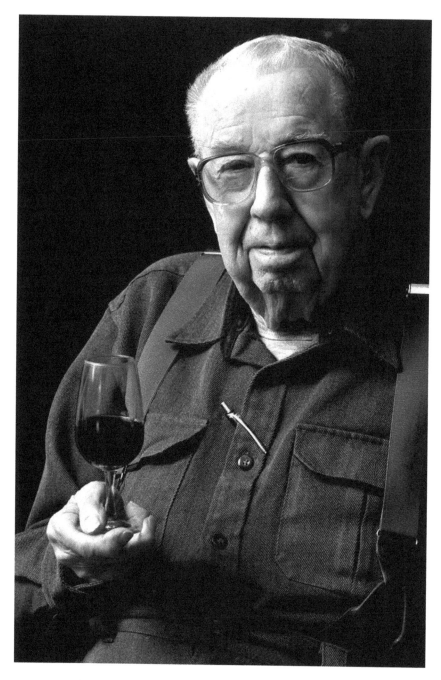

Bernie Rink, Winemaker

I first met Bernie Rink when he ran the Osterlin Library at Northwestern Michigan College.
He was dabbling in growing grapes and had bottled some wine. I was told it wasn't too bad,
and there might be something there. There was. As one of the first wineries in northern
Michigan, Boskydel became a must-stop while in Leelanau County. During a relaxed
photography session, I sat with Bernie in 2015 by his wood-burning stove drinking a glass
of wine while he recited poetry. He enjoyed visitors but was a little camera-shy.
He was one of the first to put the region on a global map for excellent wine.

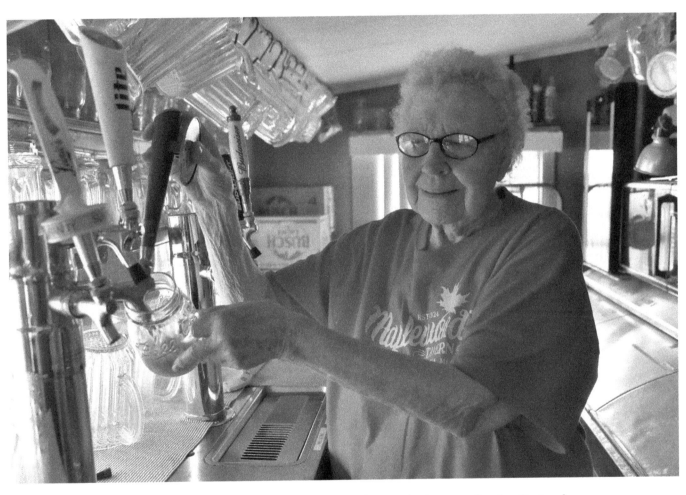

Clarise, the Longest-Serving Bartender

Clarise Cadarette Grzenkowicz was recognized by the Guinness World Records
as the world's longest-serving bartender, pouring beer for customers at the 94-year-old
Maplewood Tavern north of Alpena. Clarise was 99 years old (you wouldn't have known it)
when I wrote a story about her for the *Detroit News* in 2018. Patrons traveled from all over
Michigan to meet her, enjoy libations, and to dance to live music on a hot Saturday evening.
Cold beer and hot popcorn with Grzenkowicz made for an unforgettable bar visit.
She passed away at 102 years of age in June 2021.

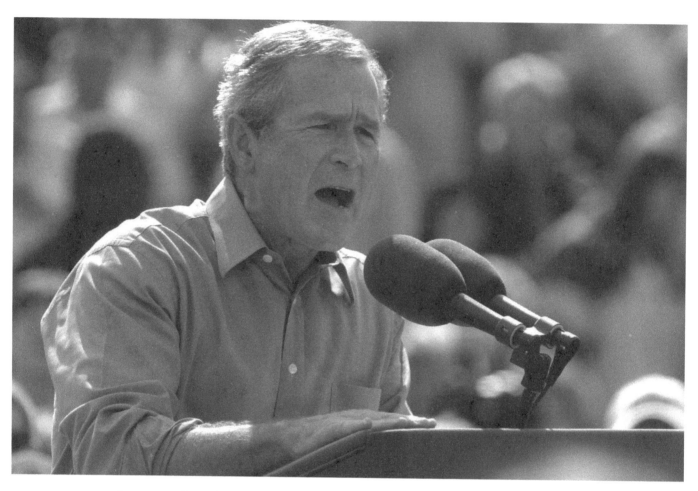

George Bush on the Campaign Trail

President George Bush campaigned in Traverse City in August 2004, becoming the first official passenger to land at the new Cherry Capital Airport on South Airport Road, which was completed but not yet open. His trip featured a rally at the Civic Center where a happy, pre-screened crowd gathered to listen and photograph the president. Being part of the press corps for any president is a rush and keeps you sharp. I took a quick opportunity to take a photo of protestors from an open window of the press corps van. I was grateful for the press corps photographers giving me a heads up on what to expect.

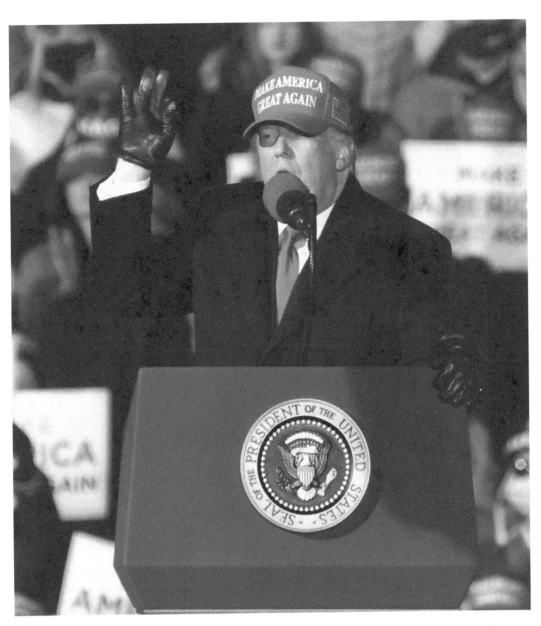

Donald Trump Visits Traverse City on the Eve of the Election

President Donald Trump spent his last evening before the 2020 election in Traverse City in the midst of the COVID pandemic. He stirred up a raucous, huge crowd of supporters, masked and unmasked, at a private hangar at Cherry Capital Airport. The need to garner votes is strong for any candidate, a thought not lost on those running for several offices and who spoke prior to the President's arrival at dusk. Like all rallies, it was a memorable evening.

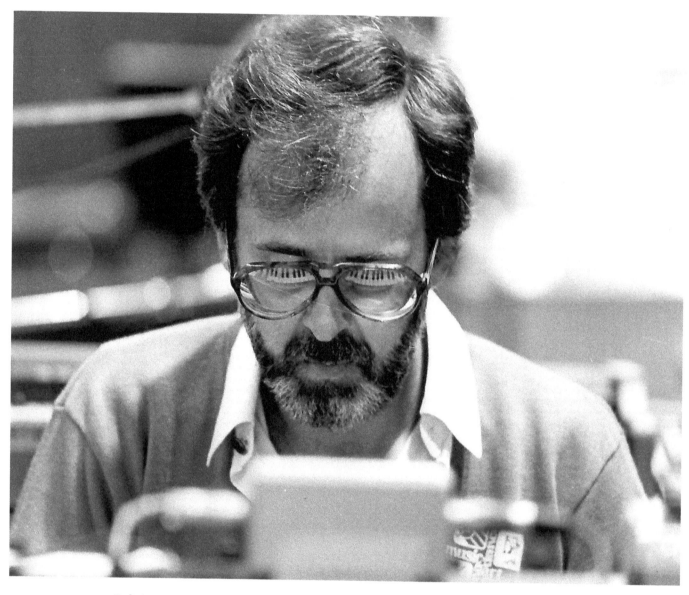

Bob James – Keys to Lashes

Pianist Bob James discovered northern Michigan when invited to perform at Interlochen Arts Academy. He fell in love with the area and found his forever home on Long Lake, where he produces music after performing on world tours. In 1987, I shot Bob for an album and learned that we share a common interest in photography.

Rev. Homer Nye

Homer Nye is a well-known Presbyterian minister who has a way with words and feelings.
He was also our next-door neighbor in Traverse City's Slabtown. Having shared his wisdom
on "Bright Spots" on the local NBC station and visiting members of his congregation for years,
Homer became one of the most listened-to and beloved pastors in town.

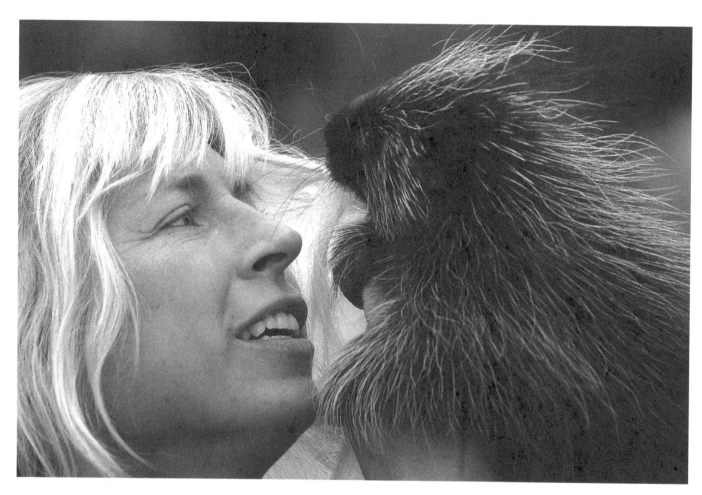

The Animal Lover

Among many friends over the years, this woman stands out as a true friend and animal lover. A keeper at the Clinch Park Zoo, Tracey Mikowski rescued and cared for anything with fur, wings, feathers or quills. An orphaned porcupette traveled with Mikowski home each night to ensure its well-being and health. She has also nursed to health baby river otters, crows, skunks and many other animals in need. After the zoo closed, she moved north to Alaska where she tends to orphaned American bald eagles, lost dogs and crows. In her spare time, she writes children's books about her beloved animals. I captured this photo in 2003, a few years before the Clinch Park Zoo closed for good.

TV Guy

Dave Fortin, a Traverse City native, was best known as a broadcast journalist. Earlier in his career he acted in Broadway shows in New York City. Returning to his hometown in 1963, he began his career at WPBN-TV as a weatherman and reporter and won many awards for his work. We attended numerous news events together, and he always had a story to tell.

He retired to Florida, where he played music and enjoyed the beach and sunshine. He and his wife, Joan, were married for 60 years. He passed away in July 2021 at the age of 81 years.

THE SPORTING LIFE

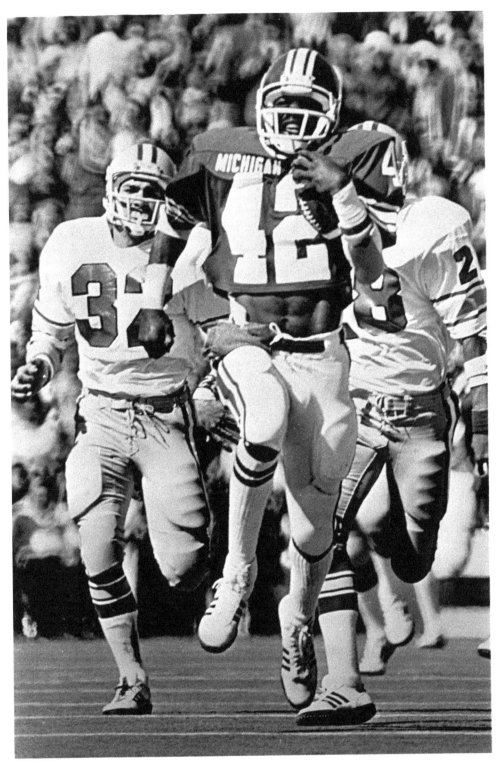

The Longest Kickoff on Record

Michigan State University's Derek Hughes crossed the 50-yard line pursued by players from the University of Oregon in what became the longest kickoff return in school history – 102 yards. I thought I was being lazy when I decided to let the play come to me at the far end of the field. But it was a lucky move; I was the only photographer that captured this 1979 record-setting run.

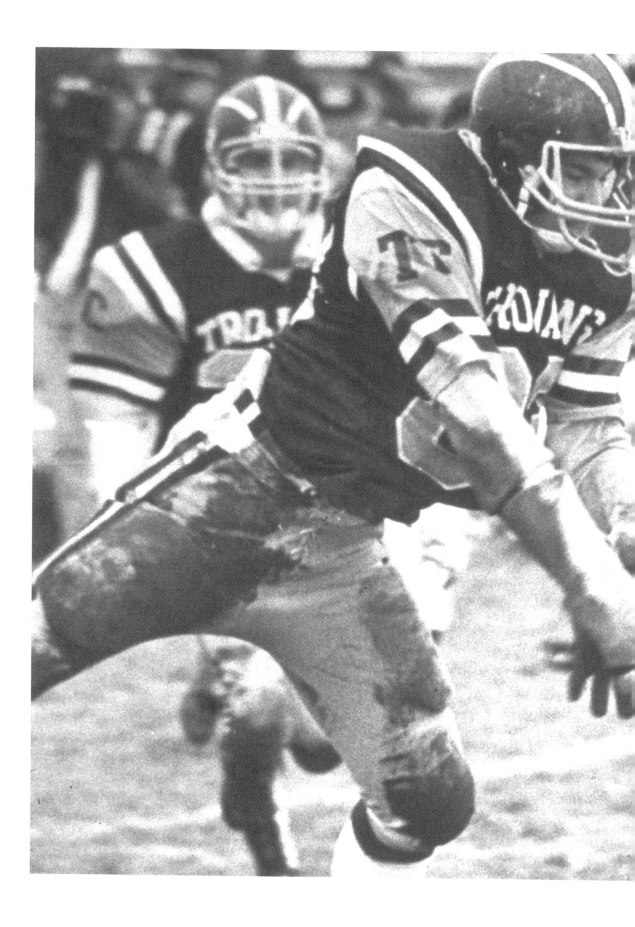

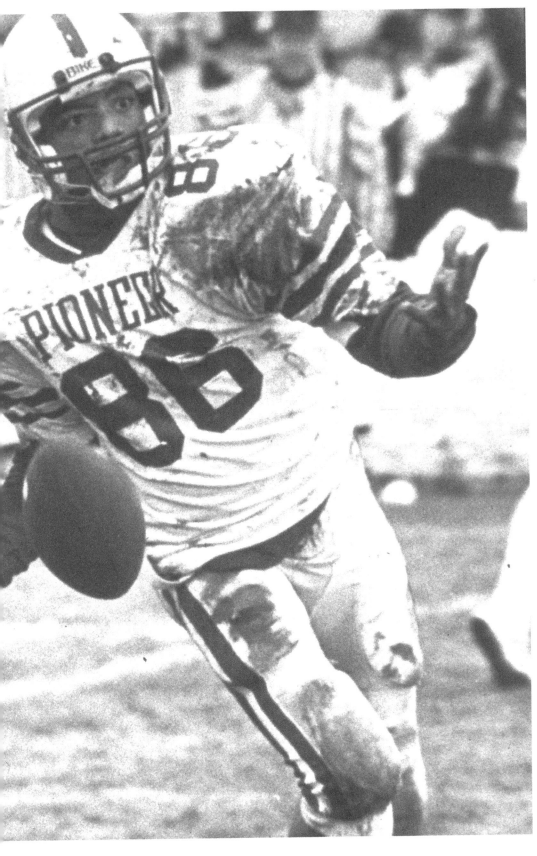

A Big Win!

Traverse City Central's Chris Valerio knocked the football from the hands of Ann Arbor Pioneer's tight end Darrell Randle in a 1985 semi-final football game in Lansing. The dropped pass came at the end of the second quarter and preserved Traverse City's win, sending the team to the state championship game at the Pontiac Silverdome. Nick Edson, the *Record-Eagle* sports editor, told me it was the most powerful and largest image that was ever printed on the cover of any *Record-Eagle* sports page.

Coach Jim Ooley

Jim Ooley won his first Class A state championship in 1978 at the Pontiac Silverdome, putting Traverse City Central on the statewide radar as a significant challenger. He won titles again in 1985 and 1988. Ooley was a passionate coach who lived and breathed football and cared deeply for his team members. He always made time to speak with the media.

Champion Coach

Jim Ooley held a championship trophy in 1985 at a rally after winning a state championship football title. He was recognized regionally, statewide and nationally for his athletic programs and success. He died at the age of 77 in 2005.

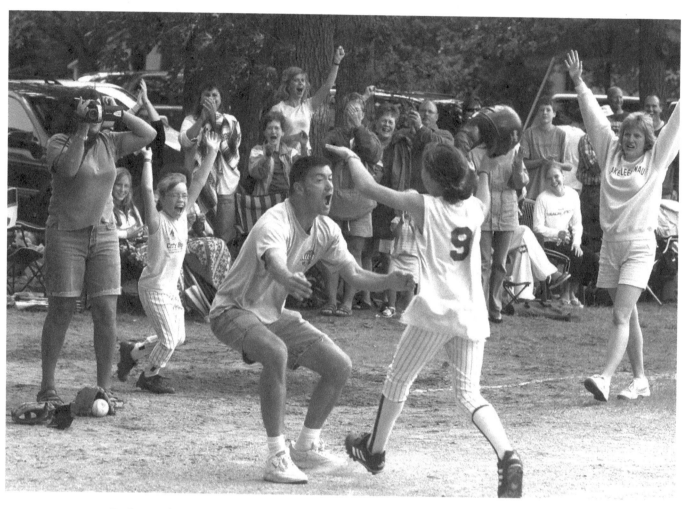

Taylor Peek Makes Her Dad Proud

Here's a photo from the nail-biting 2002 Traverse Area girls' softball C-league
(9- and 10-year-olds) championship game. Taylor Peek, the last one to bat in the last inning
with two outs, played a big part in the win. She hit a single to first, sending a player on
third base all the way to home, the winning run. Her father, Jeff Peek, was assistant coach
and greeted her with open arms, along with most of the Peek family. I used to work
with Peek, a sportswriter, and we covered a lot of games together.

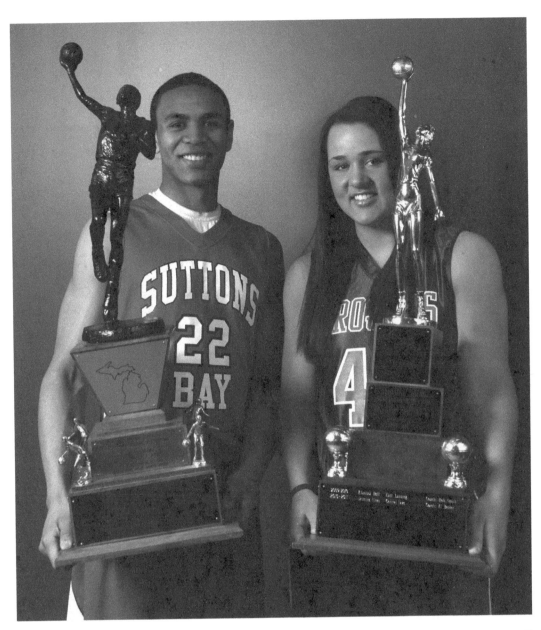

Mr. and Miss Basketball

Each year, Michigan's high school basketball coaches select and award the top male and female high school basketball athletes. In 2011, Dwaun Anderson of Suttons Bay was recognized as Michigan's leading male champion and Jasmine Hines of Central Lake was chosen as the top female basketball champion. They were thrilled to death to be asked for their autographs.

It was the first time that both winners came from the same Michigan basketball region. I set up portraits to memorialize the region's historic accomplishment. Anderson and Hines are both leaders who have set high standards for their classmates and competitors.

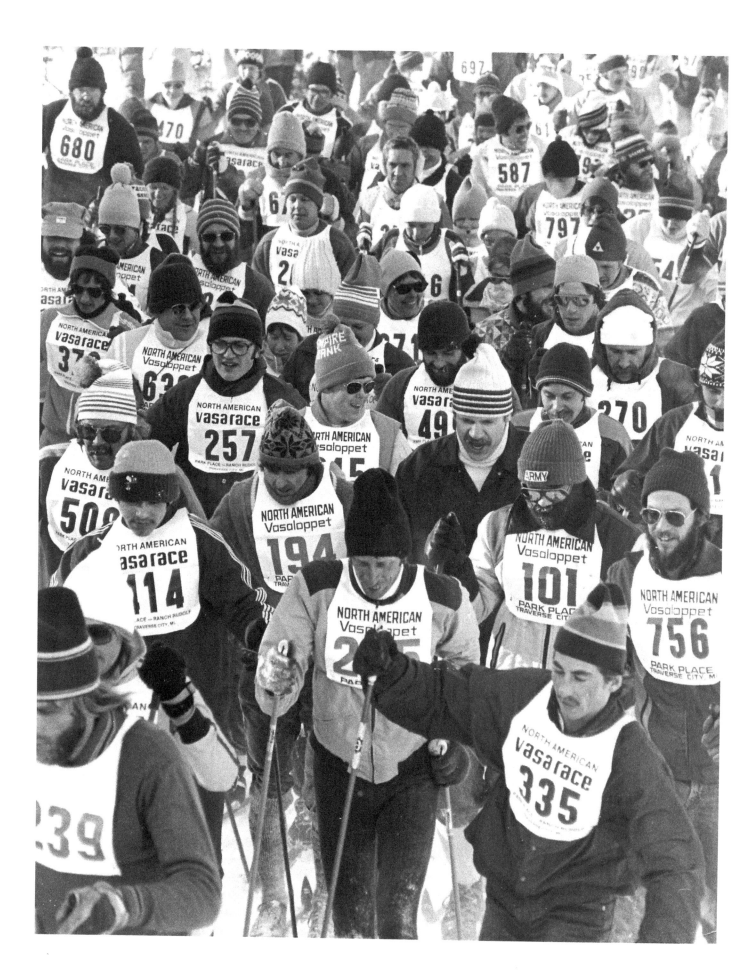

Vojin Baic Helps Make TC a Skiing Mecca

Vojin Baic, an Olympic cross-country skier, helped create the VASA race and transformed Traverse City.

In 1948, representing Yugoslavia on the national rowing team, Baic came through Ellis Island and defected to the United States. Vojin fought in the Korean War for his new country and won the Asian Military Games in Nordic skiing for the U.S. Army. After living in Grand Rapids, Vojin and his family moved in 1966 to a Sixth Street house in Traverse City, two doors west of my own family. We became good friends.

Vojin joined the Parks and Recreation Department for Traverse City and began to teach the sport of cross-country skiing.

Vojin was a tireless advocate of exercise and touched hundreds of lives at Hickory Hills and cross-country ski races. I will always hear his voice, as he shouted out encouragement. He was a good American and my favorite Serb.

Skiers Unite!

Elite skiers Vojin Baic, Ted Okerstrom and George Lombard put their dream of a cross-country ski race into motion when 234 racers took part in the first North American VASA when they left Cherry Capital Airport. A total of 205 racers reached the finish line at Ranch Rudolph.

The year was 1977, when you couldn't buy a pair of cross-country skis in town. Now the race boasts 350 volunteers, who welcome more than 800 skiers, snowshoers and fat-tire mountain bikers each year to challenge themselves in the snow.

Today, the VASA's vast trail system is used year-round by bicyclists, skiers, runners, walkers – nature lovers, all.

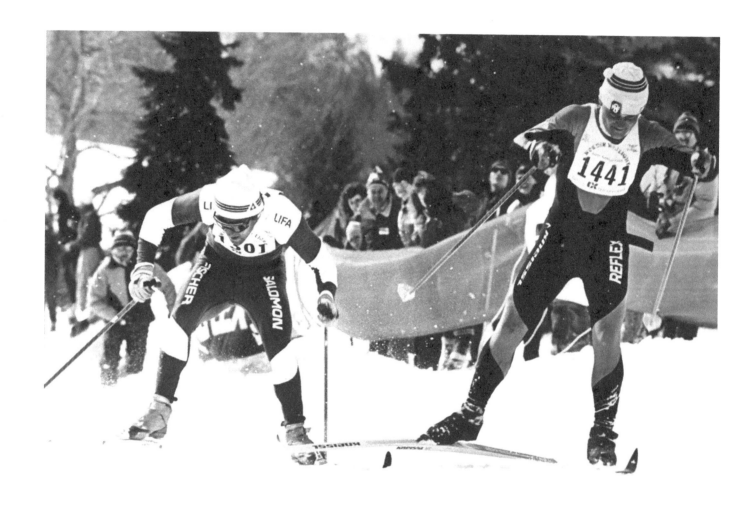

A Fall to the Finish

Steve Poulin, left, sprinted to the finish of the 50 km VASA race trying to pass
Armund Drivenes, but caught a ski and fell. The situation called for a decision;
there was no immediate winner until it could be resolved whether Poulin was tripped.
Drivenes was declared the winner after this image was used to prove that Poulin's fall
was a simple accident.

Coach Jerry Wins #8 Championship!

Traverse City Central High School coach Jerry Stanek's boys' and girls' alpine ski teams won a double state championship on Feb. 28, 1995. I was in a hurry to develop the film but held off, even after all the other media left. I was hoping the celebration might offer a good image. And I was right–this image was well worth the wait. The skiers held their coach aloft, much to his surprise. Under his leadership, the teams won the top state alpine title an astonishing eight times.

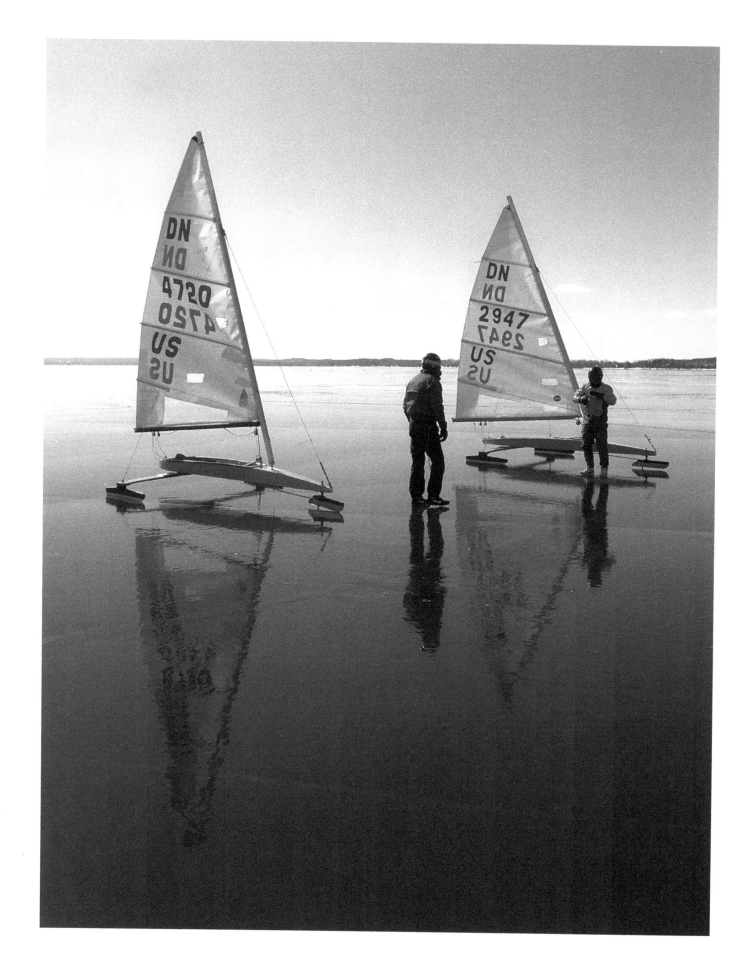

Sailing on Ice

(Facing page) Iceboating on new ice on Elk Lake in 2005 attracted sailors from throughout the Midwest to northwest Michigan for racing and camaraderie. The single-seat boats can easily attain speeds of over 50 mph, so safety is of the utmost importance.
The Grand Traverse Ice Yacht Club is well known for its championship racing, food, fellowship and sailing on the best ice in the region.

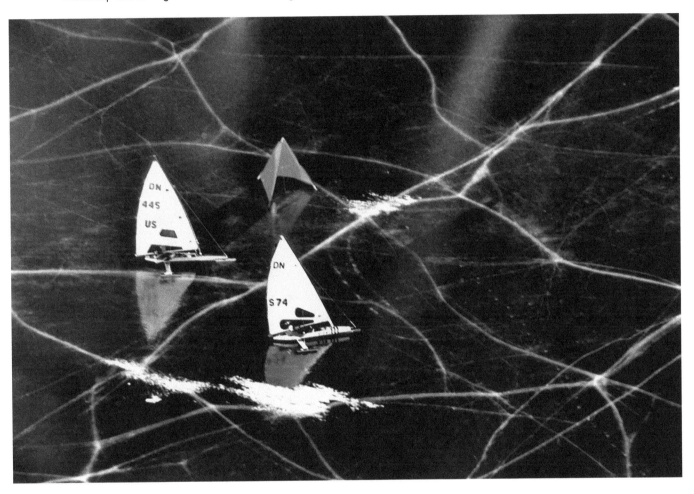

World Cup Race

Here's a shot of two DN-class iceboats racing around the weather mark on Green Bay during a Gold Cup world championship race in 2007. I was commodore of the Grand Traverse Ice Yacht Club and flew over in a twin-engine airplane to witness and photograph the races. We began our flight home by circling the final race, and I shot images from 400 feet while circling the course. This image was published in international sailing magazines and remains a favorite iceboat image of mine.

Gordie Howe

Gordie Howe held his two-year old granddaughter Jade Roscam at a 1989 dedication of Traverse City's first rink, Howe Arena, at the Grand Traverse County Civic Center. Howe and I had lunch a few times, and we talked hockey and living up north. He and his wife were wonderful, kind people. He always had time for a photo or autograph.

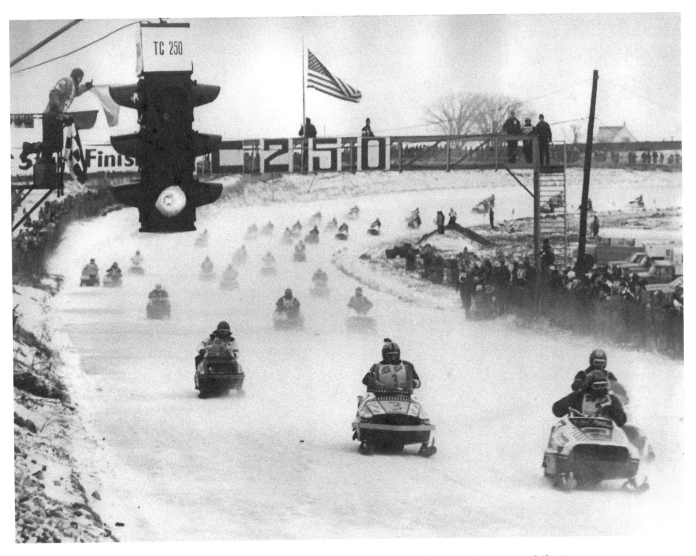

The TC 250 Snowmobile Race

The TC 250 was a popular snowmobile race once held on an oval track south of Traverse City. Racers from all over the United States and Canada competed on the circuit for prize money and fame within the snowmobile racing community. It was always cold, snowy and loud – a challenging event to photograph. This 1978 race was no different.

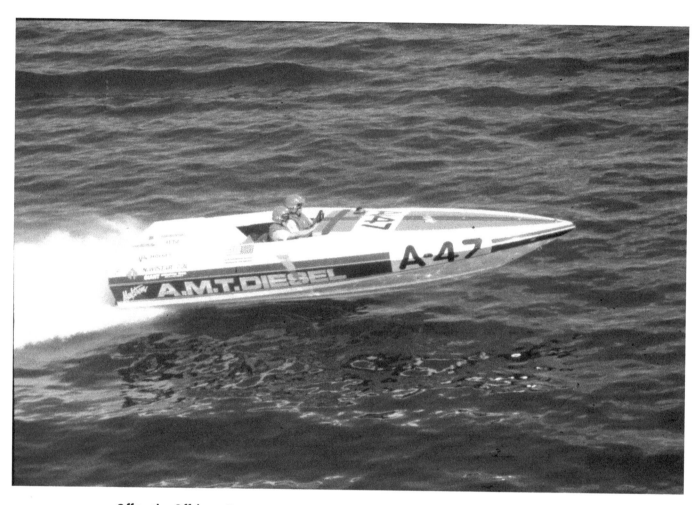

Off to the Offshore Races

The Leelanau County town of Northport was a loud and busy place for three years, 1983 to 1985, when the American Power Boat Association held offshore races on Grand Traverse Bay during the Northport 200.

The race had divisions from small twin-engine boats to super boats that could run well over 100 mph with twin hulls and four huge engines. Thousands enjoyed the races, and there were parties over a long weekend of fun. The race moved to the south of the bay, morphing into the Traverse City 200 for a couple of years until the American Power Boat Association ended the event.

I shot from the open door of a helicopter to get the best images. The boats were fast-going 120 knots – and still pulling away from us. The pilot sometimes flew so low that water splashed on me from the boats below. I was snugly harnessed in so I wouldn't get sucked out. A fun photo assignment. Noisy, but fun.

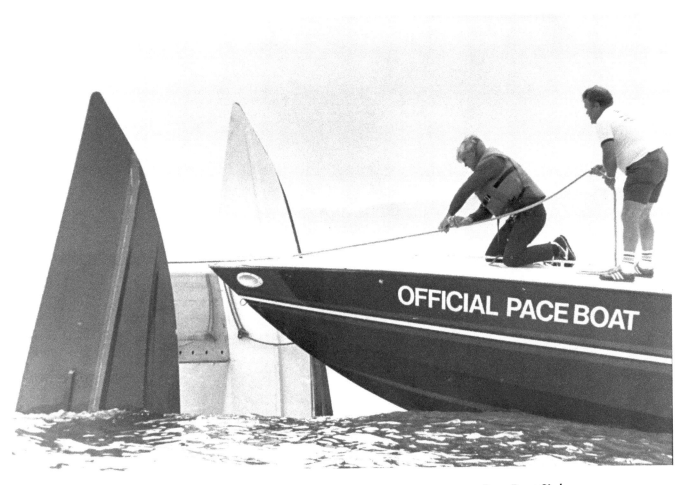

Race Boat Sinks

Sam James cuts the towline to his $1 million super boat in Northport Bay. The boat sank after James hit a log at a speed of 112 mph during a timing run for the upcoming Northport 200 offshore power boat race. The collision tore off the starboard drive unit, and the 48-foot boat sank in 125 feet of water. It was recovered by a barge and crane three days later.

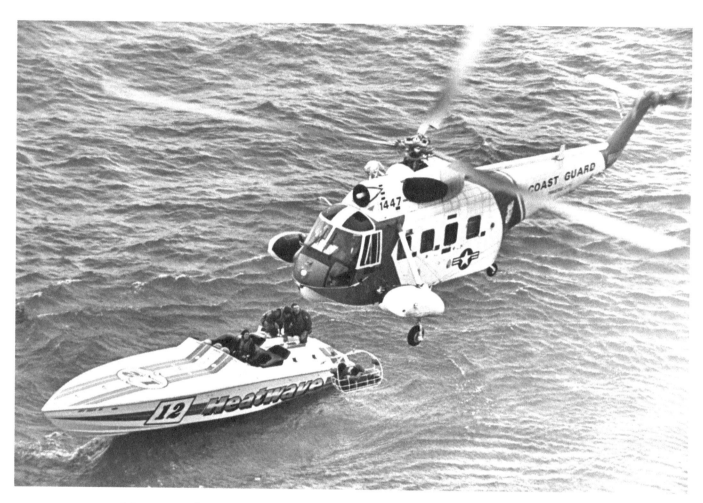

A Coast Guard Rescue

Power boat crewman Bob Kaiser was airlifted off the deck of a Northport 200 race boat by a U.S. Coast Guard HH-52 helicopter. He had injured his back during the last race in Northport in August 1985. I was riding in another helicopter to photograph the race.

Hobie and Hobie Cats

Hobie Alter changed the world of sailing when he designed the 14-foot Hobie catamaran sailboat – you know them as Hobie Cats. While attending a national catamaran sailing championship in 1985, I was able to talk my way onto a sail and take photos of him on his new 18-foot catamaran. After I got my shots, he tied the camera, wrapped in waterproof housing, securely to the mast so it wouldn't get soaked. We ended the day with a leisurely sail and talked about how and why his new boat was faster and easier to handle.

Shooting the Traverse City Beach Bums

One 2007 evening in the dugout, a player asked if I could photograph the ball
in the same frame as the batter. Being an optimist, I said I could. And I did. I caught
Mike Epping as a ball hit his bat, breaking it. Luck is always good to have with a camera,
although a *National Geographic* editor once told me that good photographers are lucky
a lot! That's a nice compliment.

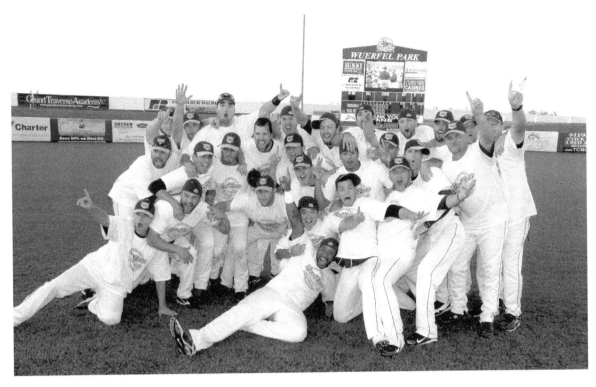

Frontier Division League Champions

The members of the Traverse City Beach Bums celebrated winning the division championship
in 2012 for the Frontier League at Wuerfel Park. It's easy to capture joy with this team;
they were a great group of ballplayers.

Suntan bites Bill Erickson

Williamsburg resident Bill Erickson attended
a Beach Bums baseball game at Wuerfel
Park on a warm summer evening.
After teasing Suntan, the team mascot,
Erickson discovered a bear can completely
mouth a human head. Without slobber.

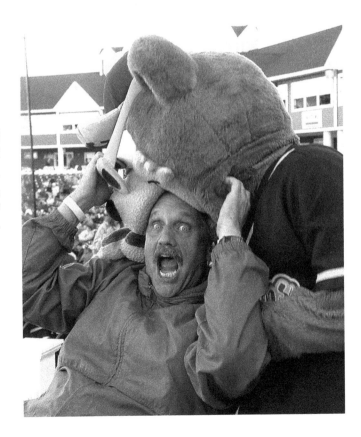

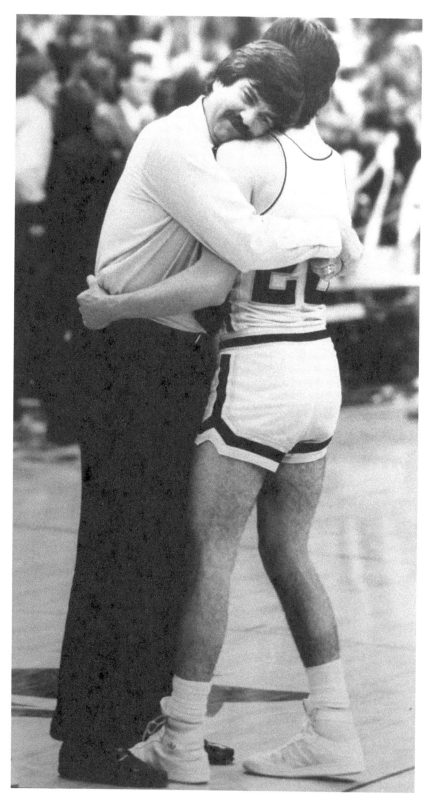

A Consoling Hug

Don Miller hugs senior Mike Crinion during a semi-final loss in 1985. It was the last game that Crinion would play as a Laker. I included this photo because Don Miller was a caring coach, unafraid to show affection to his players.

The Glass Dynasty of Leland

Olympian Alicia Glass

Leland volleyball player Alicia Glass is one of Michigan's greatest high school volleyball players, smashing records in Michigan and nationally. She was named Ms. Volleyball for the state of Michigan and the Michigan Gatorade High School Player for volleyball. Coached by her mother, Laurie Glass, she earned all-state honors during all four years of high school and led Leland to a Class D state championship.

She went on to become an All-American at Penn State where she was a setter, won All-American honors three times, and led the team to three NCAA consecutive championships. After college, she has amassed many honors, including a bronze medal at the 2016 Olympic Games in Rio; a gold medal in the 2014 World Championships; a silver medal at the 2011 World Cup and the 2015 World Cup; and she has won three gold medals in the World Grand Prix from 2010–2012. She also bronzed in the World Grand Prix in 2016.

Alicia also played on the U.S. women's national volleyball team from 2009-2016 and with the Italian club Imoco Valley Conegliano. She is a classy lady, and it was always a challenge to capture her on the court since she moved so fast.

Leland Basketball Coach Larry Glass

Larry Glass, Alicia's grandfather, also made a significant mark in Leland, coaching Leland girls' basketball team and leading many young ladies to successful careers. He brought Class D state championship titles to Leland from 1980 to 1982. He was honored as Class D Coach of the Year in December 1980.

Leland Volleyball Coach Laurie Glass

Laurie Glass, Alicia's mom, coached her daughter's team and was named Coach of the Year during her daughter's tenure. She began her coaching career with Leland in 1990, leaving twice to coach elsewhere and returning to Leland where she excelled. The Leland Comets won volleyball state titles in 2002, 2006 and 2015 and were runners-up in 2005 and 2014.

Glass has posted a record of 1,040-319-113 over her career and was honored as the 2015 National Federation of High School Volleyball Coach of The Year.

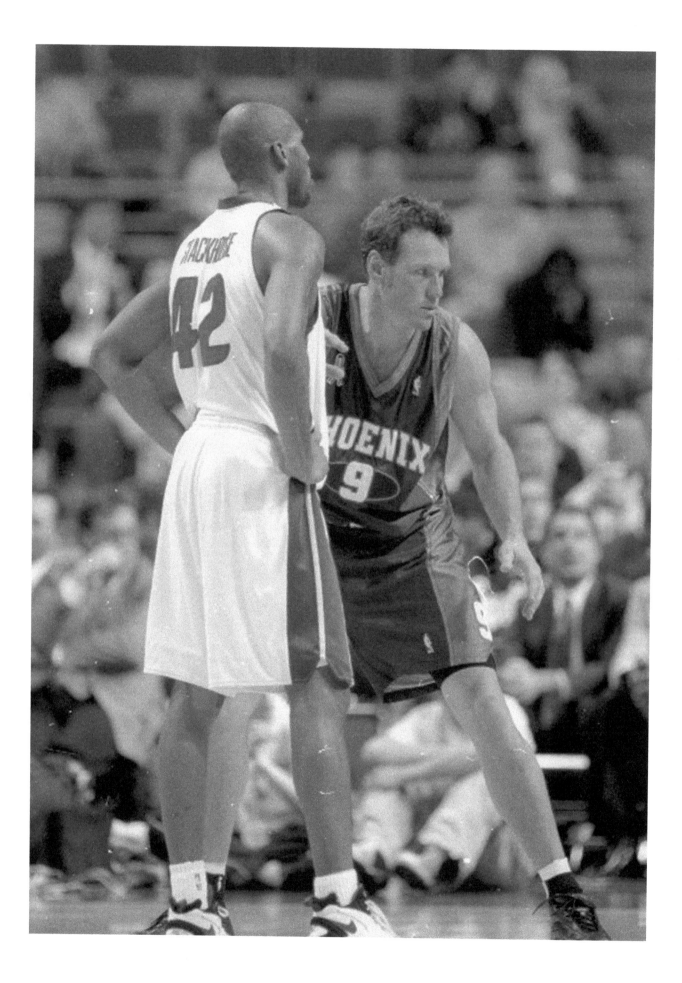

Thunder Dan Majerle

Traverse City Central basketball player Dan Majerle was one of the region's finest.
He played college ball at Central Michigan University from 1984 to 1988. He also competed
in the Olympics. His NBA career spanned from 1988-2002, playing for the Phoenix Suns.
This photo captures Majerle playing his last game in Michigan against the Detroit Pistons.

Majerle Honored

In January of 1995, "Thunder Dan" Majerle had his basketball jersey retired at
Central Michigan University. As was the custom for CMU students to honor their own, a shower
of toilet paper filled the arena, much to the delight of Traverse City's favorite son.
He now owns two restaurants in Phoenix.

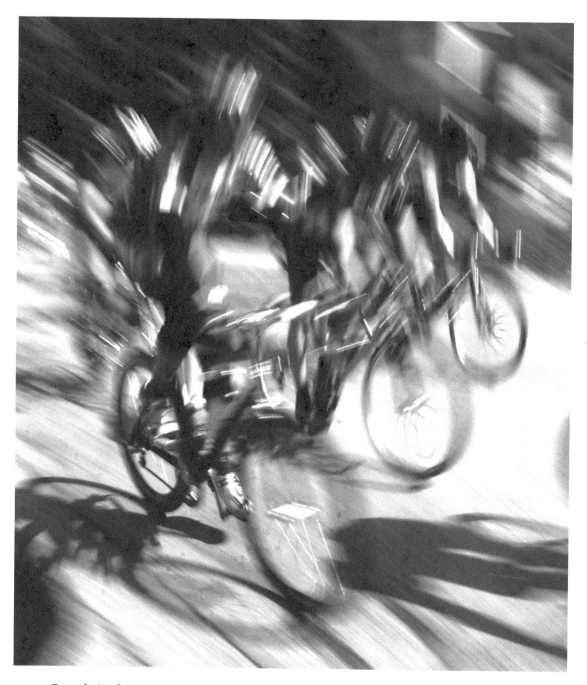

Tour de Leelanau

The Tour de Leelanau bicycle race took place over several years with some of the country's top road racers spinning through Leelanau County. Both women and men pedaled in separate races through the scenic and hilly county. The cyclists raced elbow-to-elbow at breakneck speed on roads closed for the race – through villages and intersections.
The race courses varied from year to year, but could be up to 100 miles long. The cyclists were really friendly and cheered each other on – sportsmanship at its best. I was in front of the race, shooting from an older Corvette.

Iceman!

Brian Matter, covered in mud, won the annual Iceman Challenge mountain bike race in 2010 after riding 30 miles of woods and trails from Kalkaska to Acme's Timber Ridge. I have covered most of the two dozen races and find it a challenge to shoot because the 5,000 cyclists immediately go into the woods. Fortunately, I know the back roads and course well enough to get images of both the leaders and riders back in the pack. Sometimes the finish line offers the best image with its almost-guaranteed drama.

Iceman Cometh Challenge

Here's a picture of the 2007 women racers starting the annual mountain bike race in Kalkaska in Bell's Iceman Cometh.

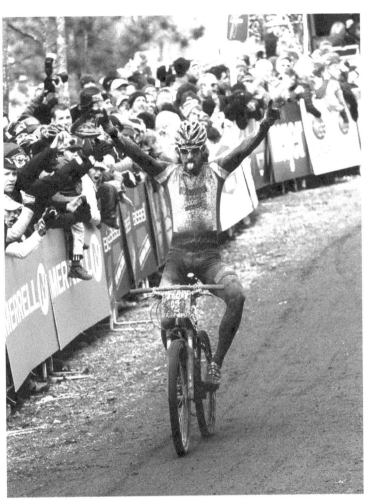

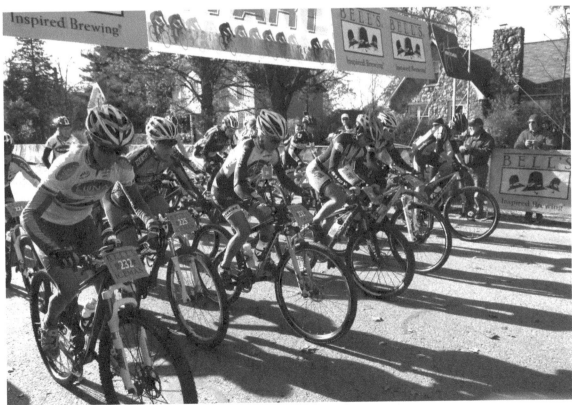

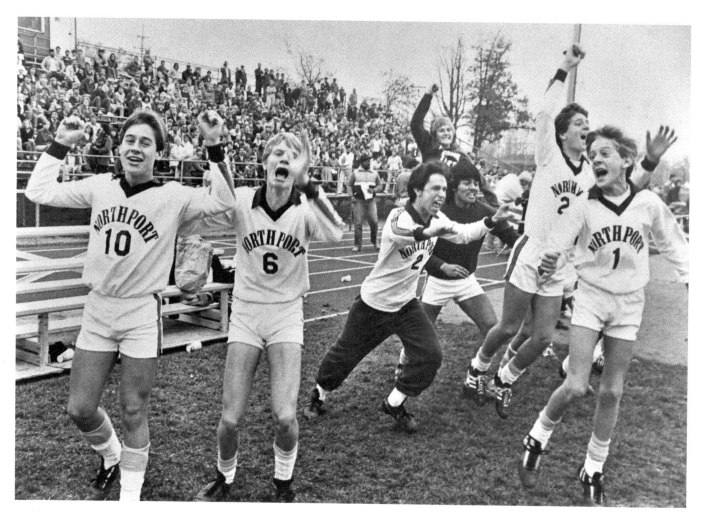

Wildcats' Win

My father was born in Northport, and we spent summers there as children, enjoying the freedom of youth. We knew many of the families whose children played sports. The Northport Wildcats won their first state high school championship ever in a soccer contest in 1986. It was a thrill to follow these young men to the title and their jubilant celebration at home.

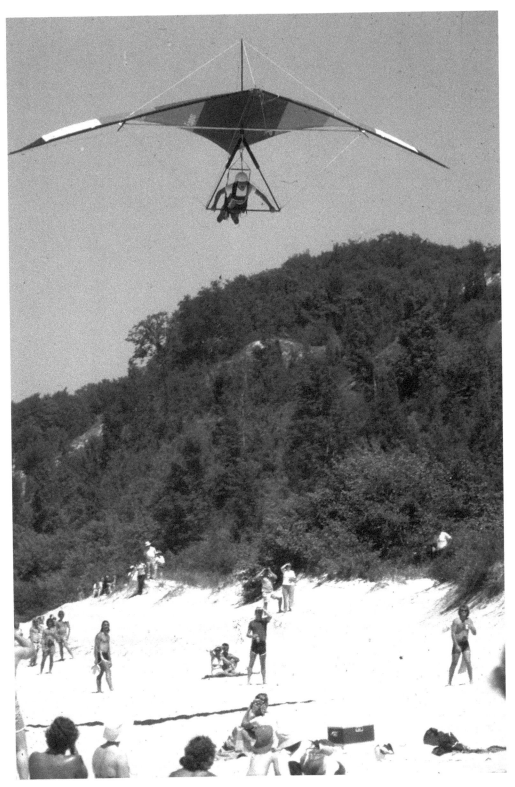

Hang Gliding

In the late 1970s, Elberta became Michigan's unofficial hang-gliding capital, with all sizes and colors of gliders jumping off bluffs along the Lake Michigan beach. The yearly events became a much-anticipated party time, and I captured some great images. They even awarded a prize for "closest to Wisconsin" for the flier who landed farthest out on Lake Michigan.

Chapter Five

NORTHERN MICHIGAN NATURAL BEAUTY

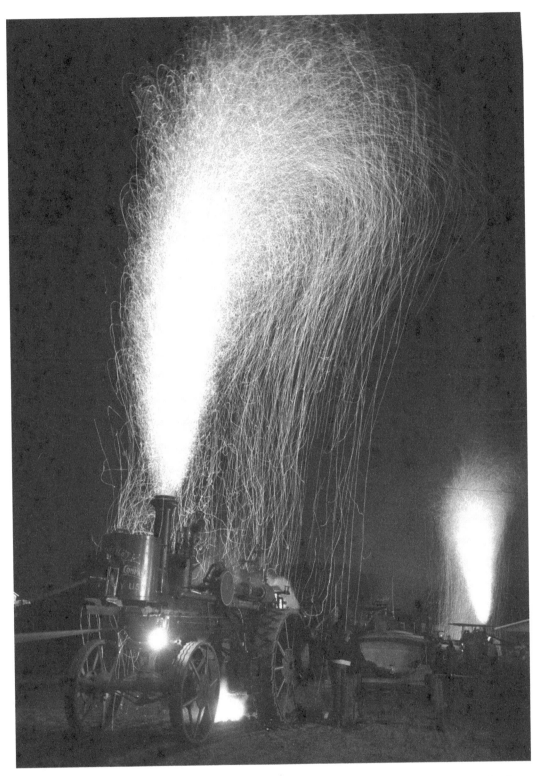

Spark Show

I had heard about the steam tractor Spark Show at the Buckley Old Engine Show and set off to capture some images. Late one evening in 2018, I set up a camera and tripod not knowing what to expect. The threshers burned compressed bundles of sawdust to create sparks that filled the sky with sparking ash, a beautiful sight. It was well worth the after-10 p.m. trek to witness this spectacle.

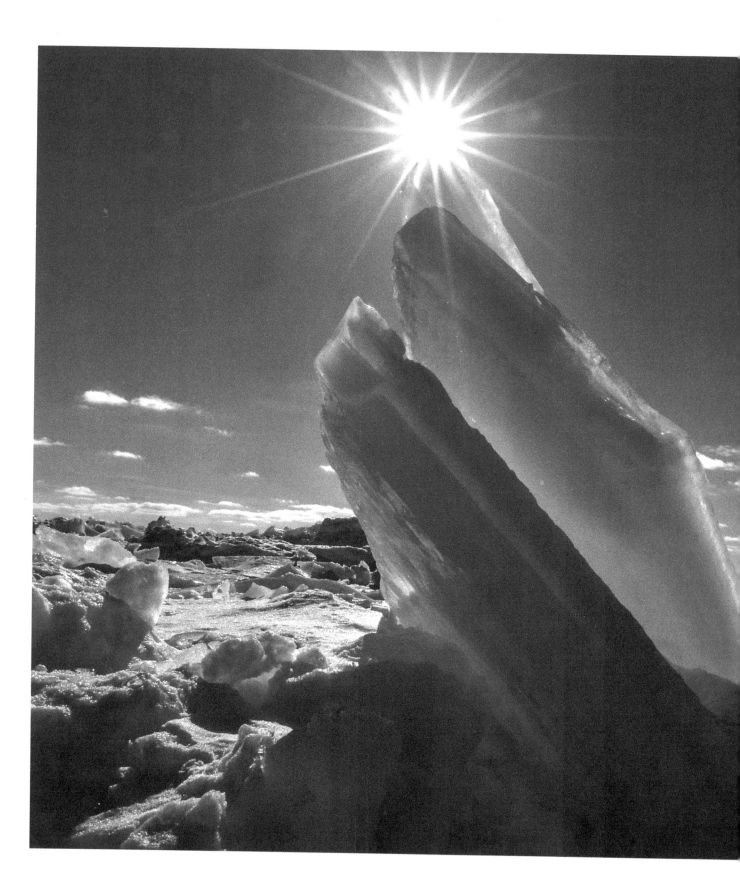

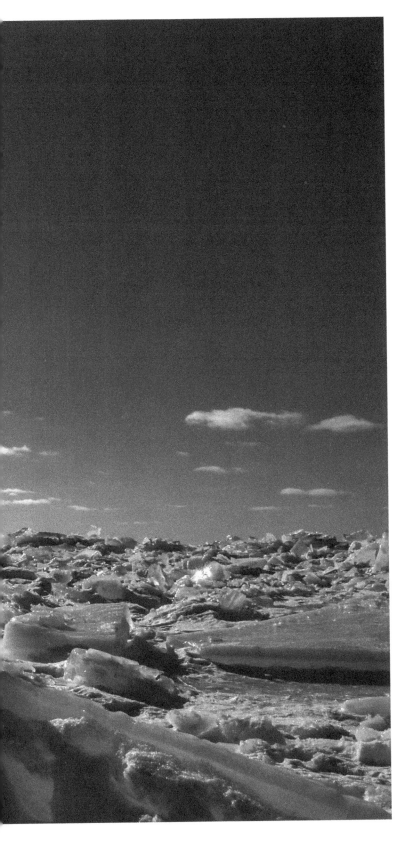

Ice Heaves

During sub-zero winter nights, Lake Michigan layered gorgeous shelves and piles of ice along the Empire Village beach. When I took this shot in 2015, I had to lay down to capture the image at a low angle. Other people on the ice hurried over to ensure that I didn't slip and injure myself. That renewed a little of my faith in good humans.

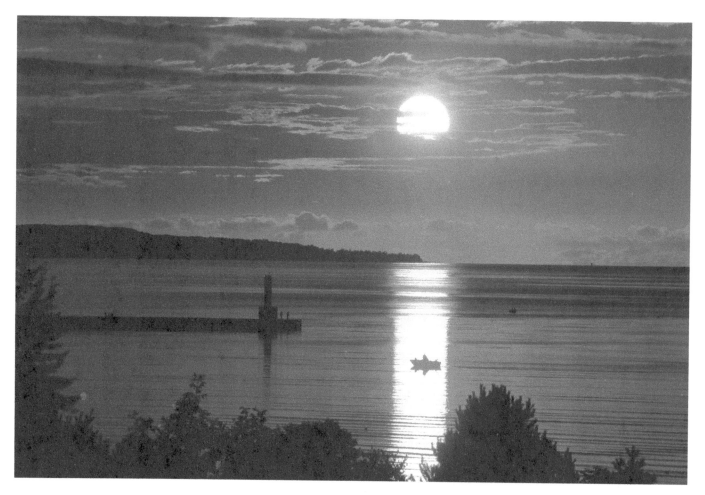

Petoskey Sunset

Returning from a Mackinac Island assignment and a day of heavy rain in 2009, the sky
over Petoskey and Little Traverse Bay cleared, creating a spectacular opportunity for
a sunset photo. Its beauty lifted my spirits and reminded me why I always carry a camera.

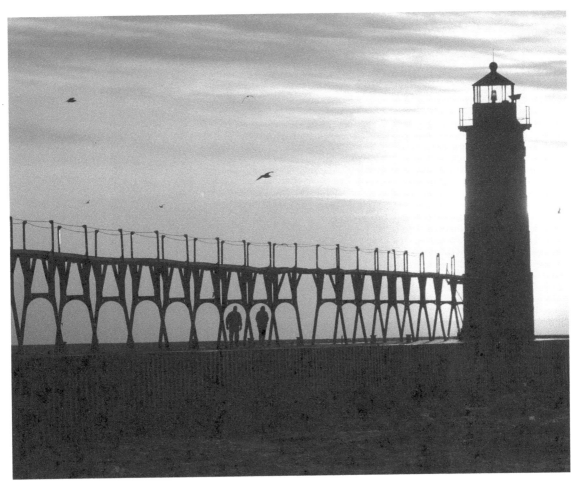

Manistee Light

Driving home after closing out my late father's apartment in Grand Haven, I chose
to visit lighthouses along the Lake Michigan shoreline. Learning the history of the lighthouses
and soaking in the shoreline beauty lessened the pain of loss a little. As the sun set
behind the North Pierhead Lighthouse in Manistee, I captured a couple walking out to
the light in the cool evening. I offered the photo to the Associated Press, which
sent it to newspapers across the United States.

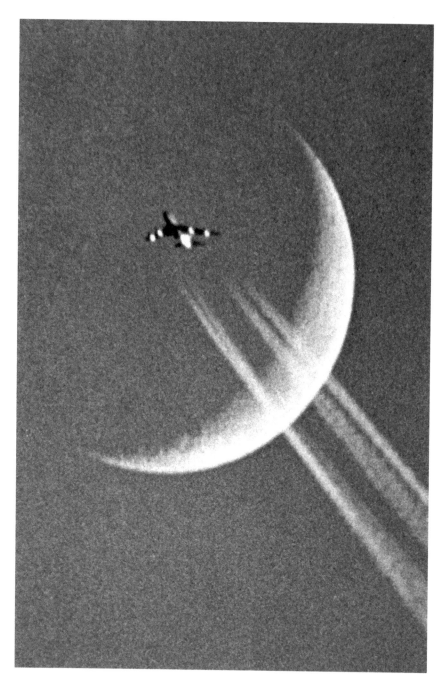

High-Flying Jet

An evening trip in 1978 to a drive-in movie in Honor found me heading west along US-31 where I spotted a high-flying jet and a waxing moon. Anticipating the possibility of the jet crossing over the moon, I pulled over and captured this image. This was better than the movie, which I don't remember.

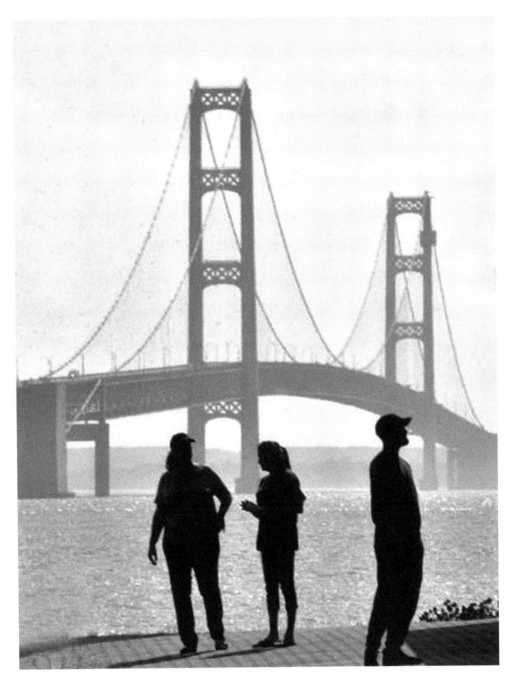

The Mighty Mac

I shot this image from the car window in 2018 as I drove into a park on the north side
of the Mackinac Bridge. My camera is always within arm's reach set for the proper
exposure for outside light so that I rarely miss a good image – that is,
if I can pick up the camera and shoot quickly enough.

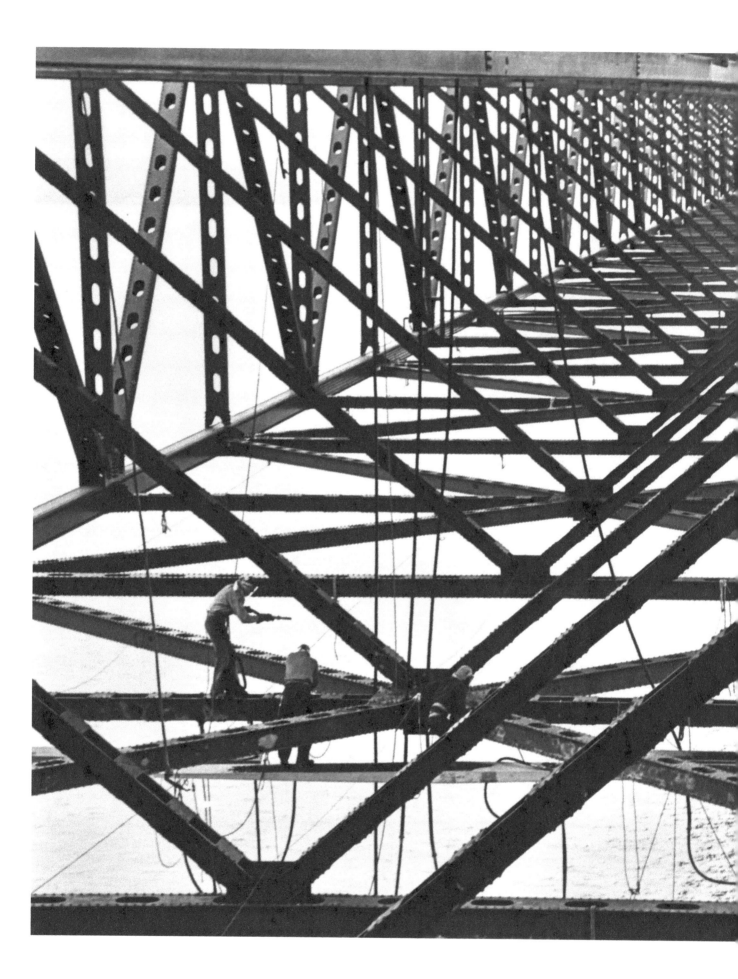

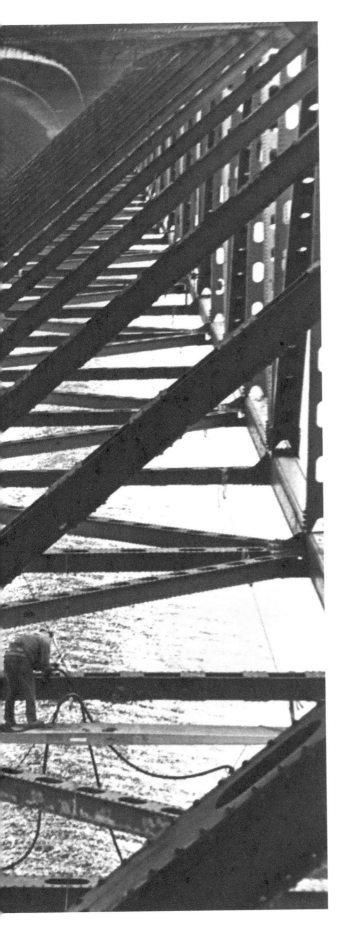

Big Mac's Underbelly

Mackinac Bridge worker Bob
Campbell took me on a tour
of the structure from top to bottom
in 1977. A paint crew was working
the girders under the roadway,
and I was struck by the immensity
of the bridge. Up until that day, I had
no concept as to how the underside
appears or how five miles of beams
hold up the roadway.

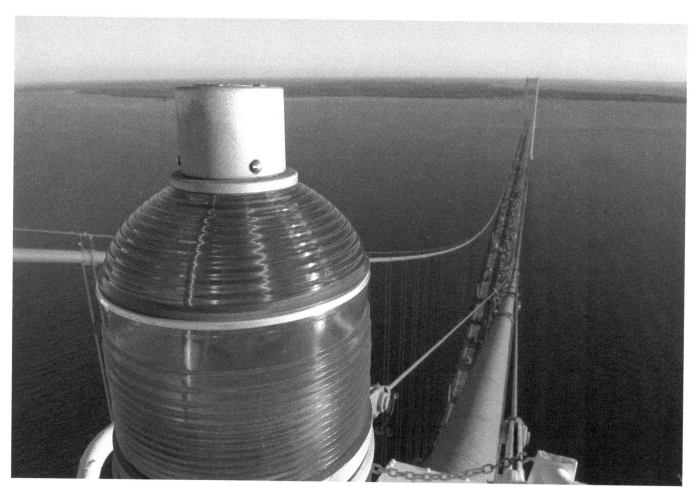

Bridge Light

As a journalist with a history of photographing more than four dozen Labor Day Bridge Walks on the Mackinac Bridge, I sometimes will take an elevator to the very top of the south tower. The little red light on the tower isn't quite so little when standing right next to it. I got this shot by holding the camera over my head to capture as much as possible – at 555 feet above Lake Huron, this isn't a feat for the faint of heart.

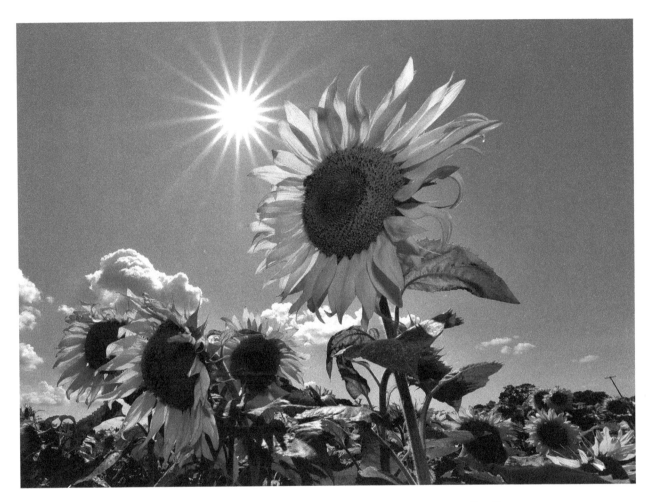

Sunflowers

I couldn't pass up a summer sun and a field of sunflowers near my home
in Williamsburg, where hundreds of acres are commercially grown for their black
oil seed. I created this favorite image of my favorite flower in 2017
by popping a flash on the camera to fill in shadows with light.

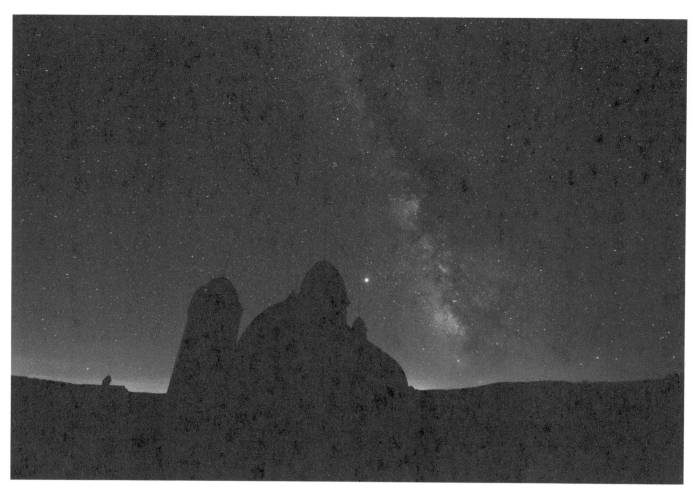

Sleeping Bear Milky Way

No matter what time of year, the night sky attracts my attention. In northern Michigan, we are blessed with dark skies and unsurpassed scenery. The Sleeping Bear Dunes National Lakeshore is a dark sky park and the D.H. Day farm is but one of many sites to view and capture the Milky Way. I captured this image in August of 2020 during the pandemic. It's comforting to know such beauty awaits me on any clear night under the stars.

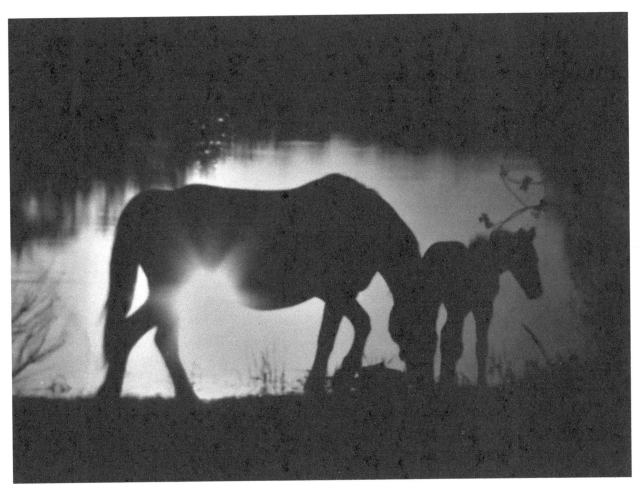

Spring Silhouette

While a student at Michigan State University, I took up the challenge of joining
the *State News* photo staff as a freelancer and always carried a camera with me.
This image of a horse and foal silhouetted against a pond and the setting sun
outside of Okemos in 1970 was a happy find.

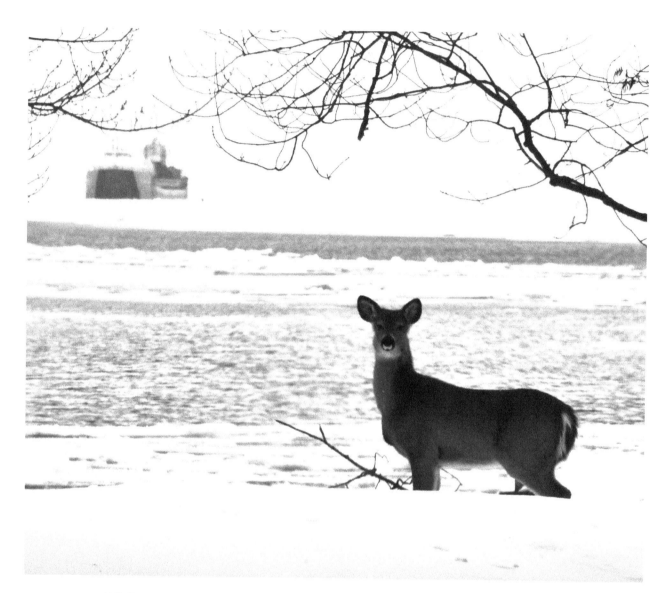

U.P. Deer

While writing about icebound Neebish Island in the spring of 2018, I took time out to cherish the remoteness and tranquility of the Upper Peninsula. Even the white-tailed deer enjoy the daylight without fear. I'm not sure what this animal would do when the freighter passed, but she ran when she saw my camera in the Jeep's window.

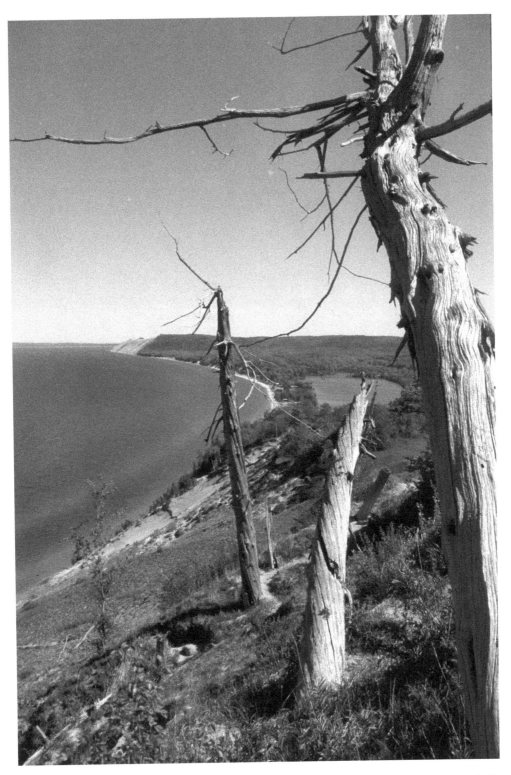

Empire Bluffs

The iconic dead trees at Empire Bluffs in the Sleeping Bear Dunes National Lakeshore, captured here in 1985, had stood through decades of wind, snow, rain and human activity. The story is that abuse by park visitors caused them to break apart, ending their existence as focal points for photographers. I miss them.

ON THE LIGHTER SIDE

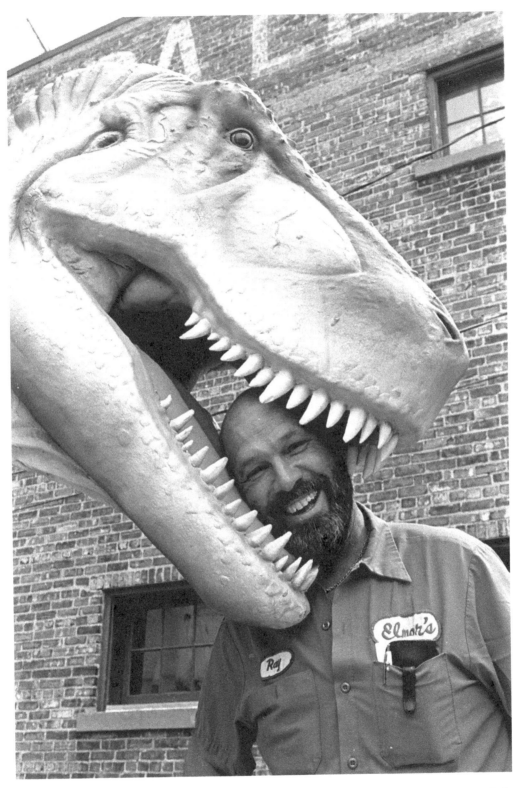

Dinosaur Bait

Ray Popp, a crane operator, was lifting several replica beasts into the Traverse City Opera House for an exhibit in 1989, giving me an idea for a funny photo. I asked him if he'd place his head in the mouth of a mechanical Tyrannosaurus rex, and he happily agreed. I have learned that if you ask someone nicely to be photographed, many times they will agree.

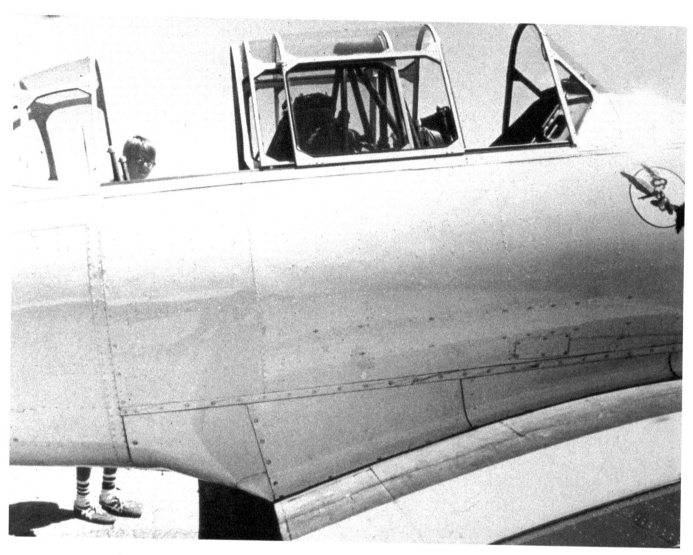

That's One Tall Kid!

At a Cherry Capital Airport air show commemorating women in flight, a youngster stood on the shoulders of his father to look into the airplane cockpit. This 1979 photo is a classic, but I wasn't able to get the names of the dad and son, losing them in the crowd after I took their picture.

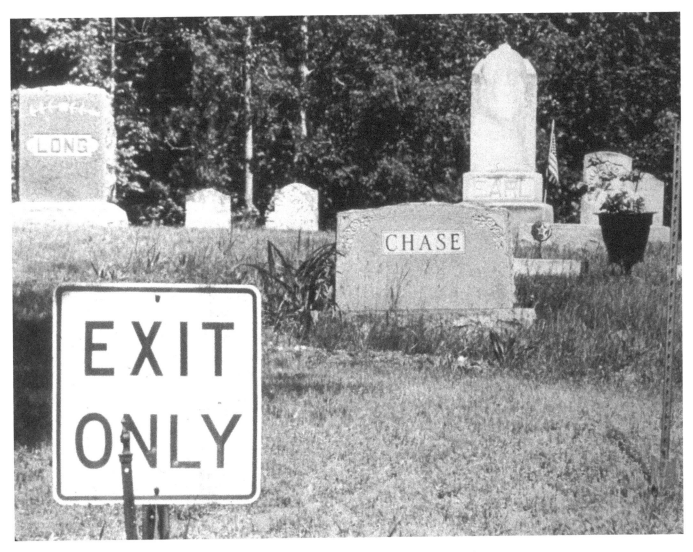

If Only it Were True!

I had driven by this small Leelanau County cemetery in the Sleeping Bear Dunes National
Lakeshore countless times. But for some reason, on June 8, 1981, I noticed this cemetery sign.
I laughed at the appearance of a promise for those interred there
and captured this image from the window of my Jeep.

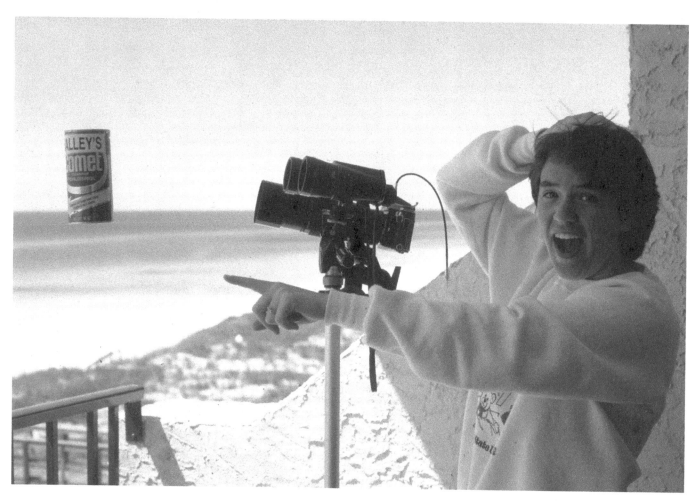

Halley's Comet … in Daylight!

Michelle McKurchie of Interlochen acted surprised that she spotted the comet on a warm, sunny day in Alabama. We had fun with this setup.

The periodic Halley's Comet returns every 75 years in our sky. That was enough of an excuse to travel south in late winter of 1985 to capture images of the apparition.

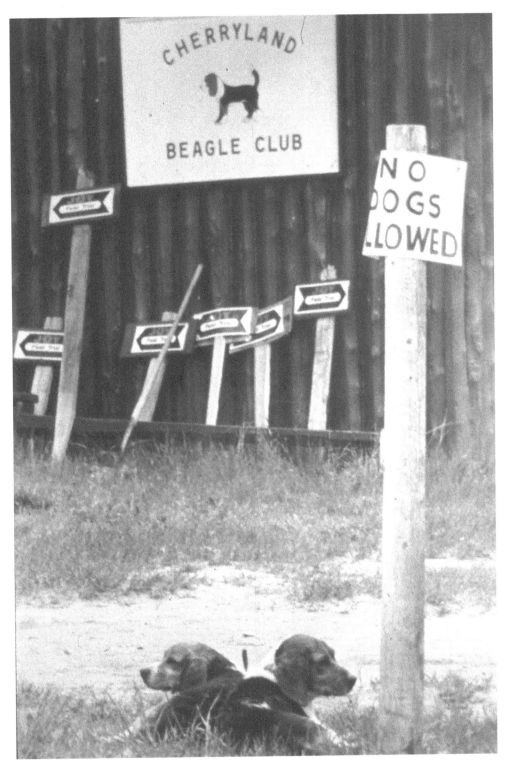

Beagle Club – No Dogs Allowed!

I have a habit of reading newspapers from the area front to back and always
take note of interesting events that are planned. The local Beagle Club was holding a meet
at the clubhouse in Whitewater Township in Williamsburg. It sparked my interest.
I chuckled to find that no dogs were allowed in the clubhouse – it actually made sense,
but I still found this image humorous.

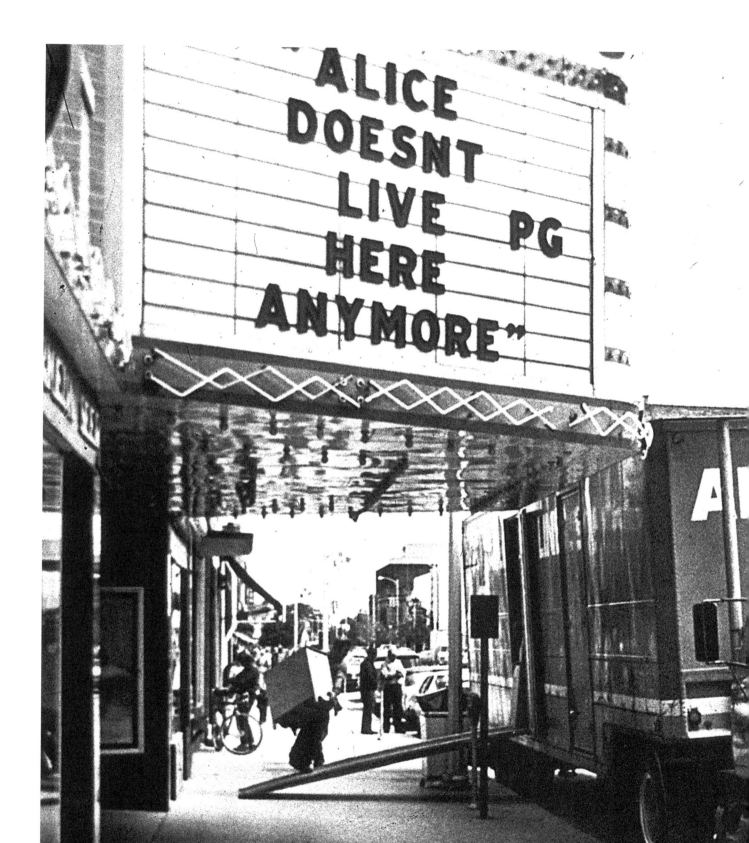

Moving Day

While walking in downtown Traverse City to an assignment in September 1975, I spotted a moving van outside the former Michigan Theatre – the only space the driver could find to move out a resident of a nearby apartment. The UPI newswire published the photo all over the world, and it received a lot of attention. It was also the first award-winning image for me at the *Record-Eagle*. Images like this make a good day better. A UPI editor I knew in Chicago asked if I had set this up. I told him I wasn't that original.

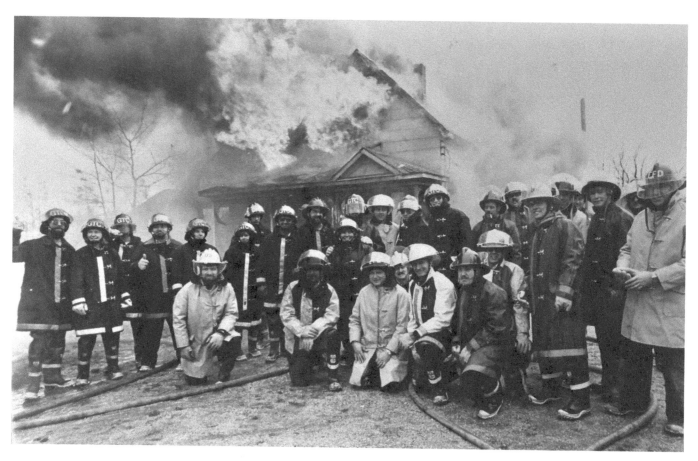

Practice Burn

Two houses on a lot in Greilickville were scheduled to be removed in April 1980 and were offered to the area fire department for a practice burn. Several departments were graduating new firefighters so the buildings were torched. I thought a graduation picture would be a fitting tribute and waited for the house to become fully involved to pose the crews.

A McDonald's stood on the site for several years before closing; the lot was eventually cleared and is vacant today.

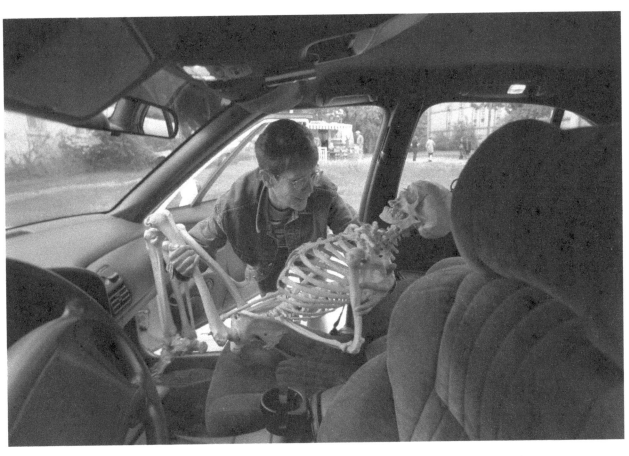

He'll Ride Skeleton!

The Northern Michigan Asylum housed up to 3,000 patients from 39 Michigan counties in its buildings, which sprawled across the west side of Traverse City beginning in 1885. The facilities were closed in 1989 and items were auctioned off in the early 1990s.

Barb Schmuckal placed a winning bid of $10 on the wired skeleton of a former patient that left his remains to the hospital, the bones used for teaching the nursing staff. Her brother is using it as a teaching aid at Ferris State University. She belted in the skeleton for safety, although it was a little late by that point.

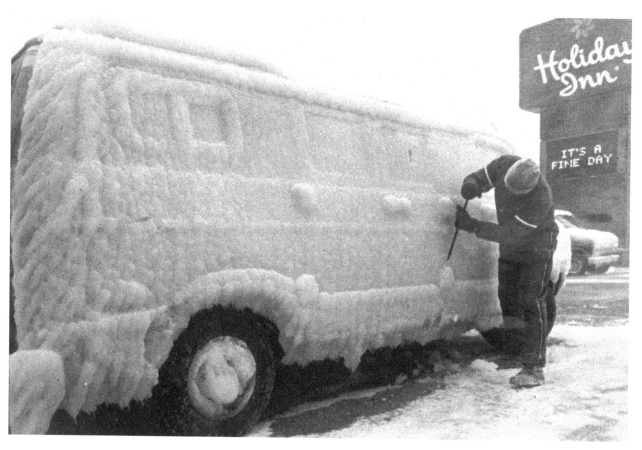

On Some Days, It Takes a Tire Iron

Jim Hendrick of Marysville, Michigan, spent a winter evening in February of 1987
at the Holiday Inn along West Grand Traverse Bay. A strong north wind crashed waves
of icy water onto the bayside parking lot, covering the van he had parked along the shore.
Using a tire iron, he slowly removed enough ice to allow him to move the van and
finally head for home.

The Williams Brothers Clean Up Traverse City ...

Each Halloween for several years, brothers John and David Williams would create unique and hilarious Halloween schemes. A copy of a huge 1962 Hoover upright vacuum cleaner turned heads at Traverse City's Open Space in 1982. A special touch – they recorded and played a sucking vacuum sound.

The men and their friends–victims of the monster vacuum cleaner – spent the day driving the machine around town and cracking people up. It was actually an Opel Kadett automobile; I have no idea what they did with the vacuum cleaner parts.

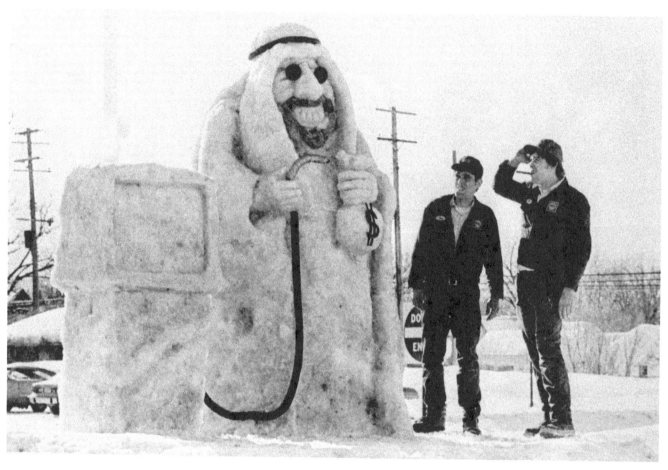

Sheikh Sculpture

Jim and Don Scharman of Kingsley were well-known in the region as ice artisans.
As gasoline prices slowly inched up in February 1977, the Scharmans decided to carve
a 16-foot-high sheikh at their Union Street gas station. It was a popular sight until
warm spring weather arrived and it melted into the parking lot.

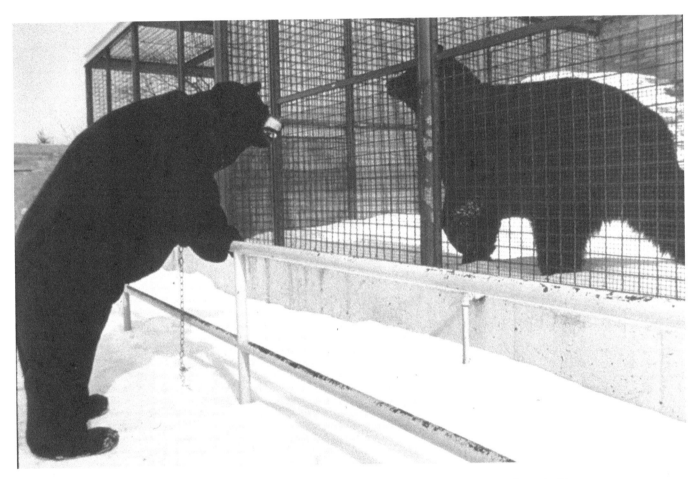

Bear-to-Bear

Interlochen Arts Academy student J. Drew Pickard was given the part of a bear in the stage production of the play "The Cave Dwellers" that featured animals in 1989. The inventive and energetic student took on the task with great vigor.

Pickard studied Lucy the bear at the Clinch Park Zoo and visited her in his full bear regalia. She had no idea what was happening and paced around her cage. When Pickard took off the bear's head Lucy relaxed. I last saw the Interlochen students as they headed downtown with the bear standing in the bed of their truck, looking to surprise people. This image was published in *The Best of Photojournalism* book.

Flag Day Flap

Flag Day is a national holiday celebrated mid-June each year. On a sunny, windy day, Harry Fuller took a lunch break from Hamilton Clothiers in Traverse City, where dozens of American flags lined the sidewalks. The "flag day flap" was captured and published on page one of the *Record-Eagle* the next day, much to Fuller's chagrin.

Lighthouse Support

Now part of the Sleeping Bear Dunes National Lakeshore, the South Manitou Lighthouse fell into disrepair in the 1980s. It made me think of an idea: How about someone stepping up to lend the structure a hand? Bob Mathews, a lifelong friend, supported the idea and posed. The structure has since been restored and shines its light during the shipping season each year.

The South Manitou Lighthouse guided ships through the Manitou Passage from 1871 to 1958 with 17 lighthouse keepers over the years living on the premises. Its 104-foot tower featured a third-degree Fresnel lens from Paris that could throw a beam 18 miles over the lake.

THE U.S. COAST GUARD: ALWAYS READY

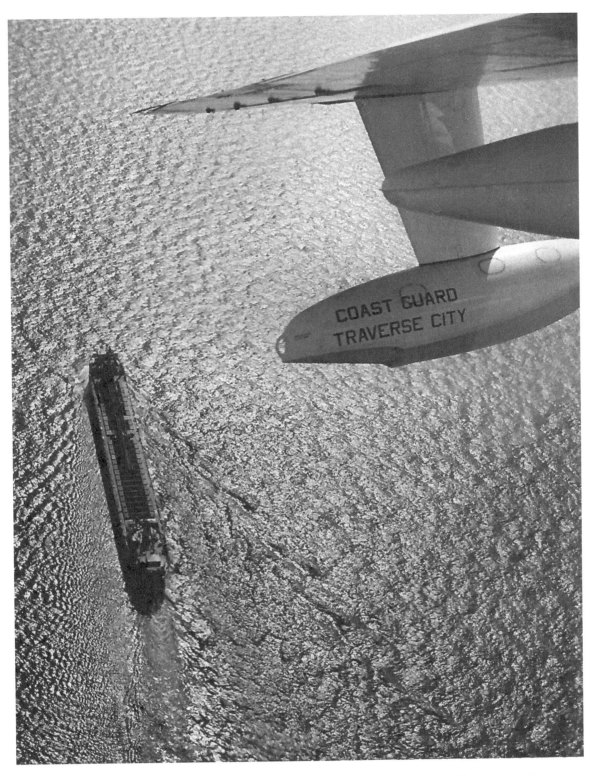

Pollution Patrol

The left wing of a Grumman HU-16 Albatross framed a Great Lakes freighter while on pollution patrol over Lake Michigan in the mid-1970s.

As guardian of the Great Lakes, the U.S. Coast Guard facility, the men and women save countless lives, assist boaters, and search for missing people 24/7. Northern Michigan is lucky to have them. Established in 1945, the air station is part of the Ninth District in Cleveland.

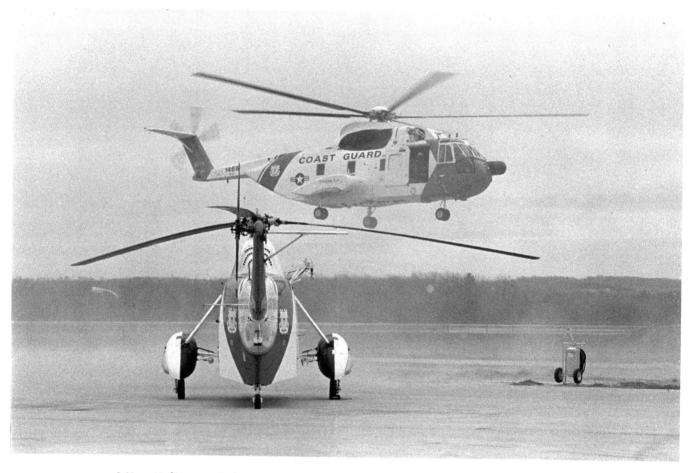

A New Helicopter Arrives

A U.S. Coast Guard HH-3 Pelican helicopter arrived in the Traverse City air station in 1991. That was a big deal, as it was a very powerful helicopter. The smaller HH-52 Seaguard helicopter awaited on the tarmac. The local air station has thousands of miles of area to cover, and the use of rotary aircraft is essential in rescue work.

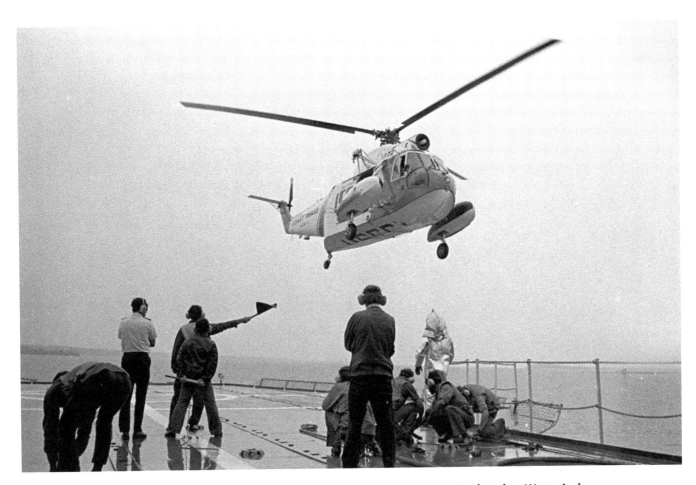

Icebreaker *Westwind*

The polar icebreaker *Westwind* was a common sight during the 1970s on the Great Lakes. Working with the U.S. Coast Guard in Traverse City, I flew out to the vessel on Grand Traverse Bay and shot images of helicopters landing and departing from its deck. Training for the pilots and crews is an ongoing part of their lives in service to citizens.

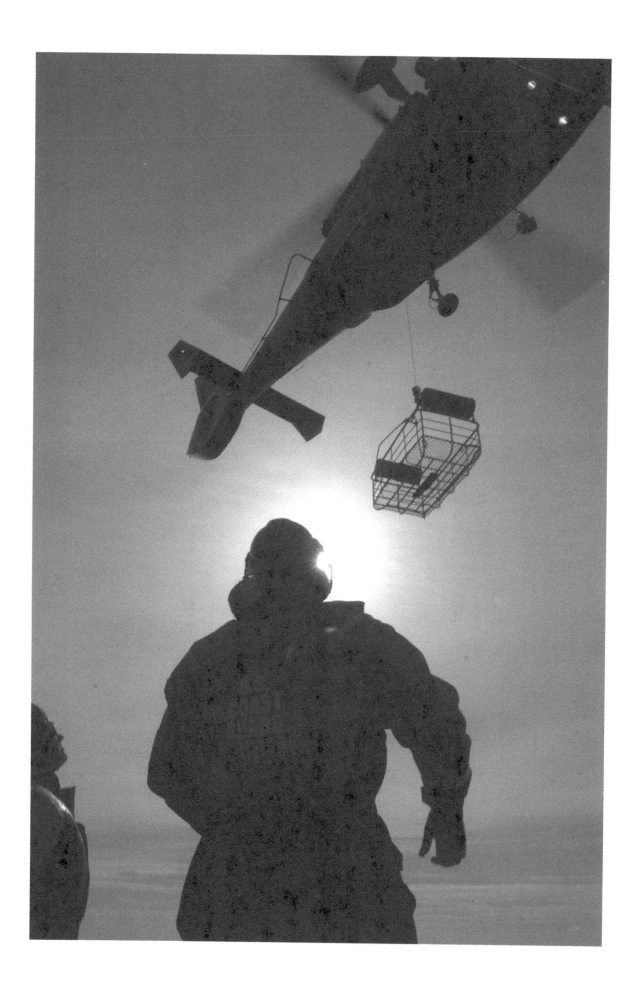

Canadians Train on East Bay

The U.S. Coast Guard's Great Lakes stations operate on the assumption that at any time they may be called to assist the Canadians in a rescue operation, so training occurs periodically to keep their skills sharp. Here, a Royal Canadian Air Force helicopter lowered a basket to a waiting boat during training exercises with Air Station Traverse City on East Grand Traverse Bay in 2015. A hovering helicopter is loud and very windy; anyone on the boat is sure to get wet.

A Repair Check of the Albatross

A Grumman HU-16 Albatross is serviced in the old hangar at Cherry Capital Airport. The Navy built the massive structure during WWII and the Coast Guard moved onto the base in 1945. This aircraft is presently displayed in the National Naval Aviation Museum at NAS Pensacola, Florida. I flew in her a number of times, as it was an excellent platform to shoot search and rescues. We had a lot more rescue activity on the ice 30 or 40 years ago – maybe boaters are safer and better educated than they used to be.

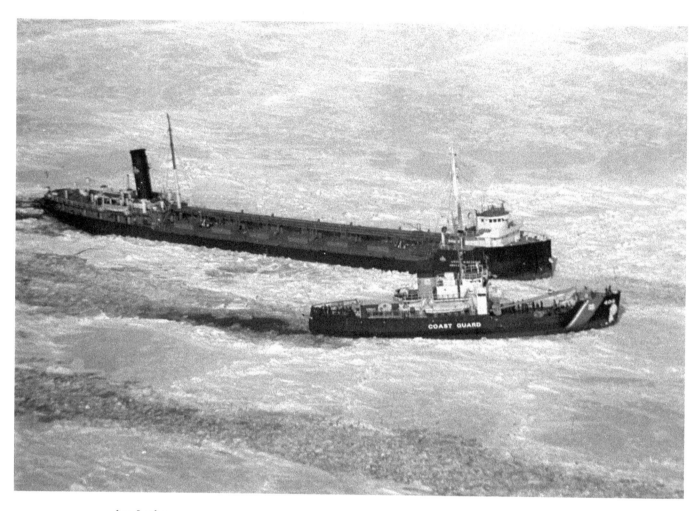

Ice Assist

The 180-foot USCGC *Sundew*, a buoy tender and icebreaker stationed in Charlevoix, assisted an Amoco oil tanker off Northport Point in 1977, when the ship got stuck in thick ice. I flew with the Coast Guard out of Traverse City to photograph the ships as they worked their way slowly into the oil docks in Greilickville. Both vessels – the buoy tender and oil tanker – are both out of service today.

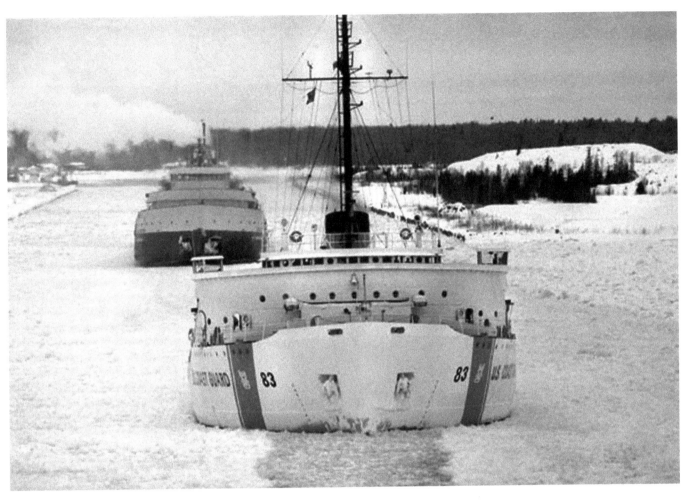

Opening The Rock Cut

The U.S. Coast Guard icebreaker USCGC *Mackinaw* clears the Rock Cut on the west side of
Neebish Island in March, 1999, cutting a path for the 690-foot SS *Courtney Burton*.
The helicopter I was in hovered ice-level for this angle, and the image is a favorite of mine,
partly due to the history: Both vessels are no longer in service.

Albatross Drops a Pump–On Purpose

An HU-16 Grumman Albatross drops a pump during an exercise at the National Cherry Festival air show over Grand Traverse Bay in 1975. The United States Coast Guard's Air Station Traverse City flew three of the amphibious airplanes as part of their service for several decades before upgrading to a fleet of helicopters.

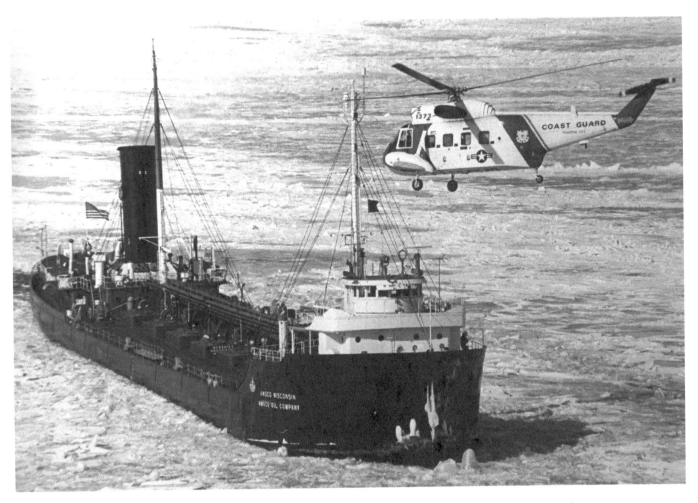

Ice Assist

A US Coast Guard HH-52 helicopter circles the *Amoco Wisconsin* as the tanker slowly works
its way through heavy ice at the mouth of Grand Traverse Bay. The Coast Guard regularly assists
winter shipping with aerial reconnaissance and ice breaking to assure steady movement
of materials. When I fly with the door open I'm wearing a gunner's belt to assure I don't
fall out and a dry suit in case of a water landing.

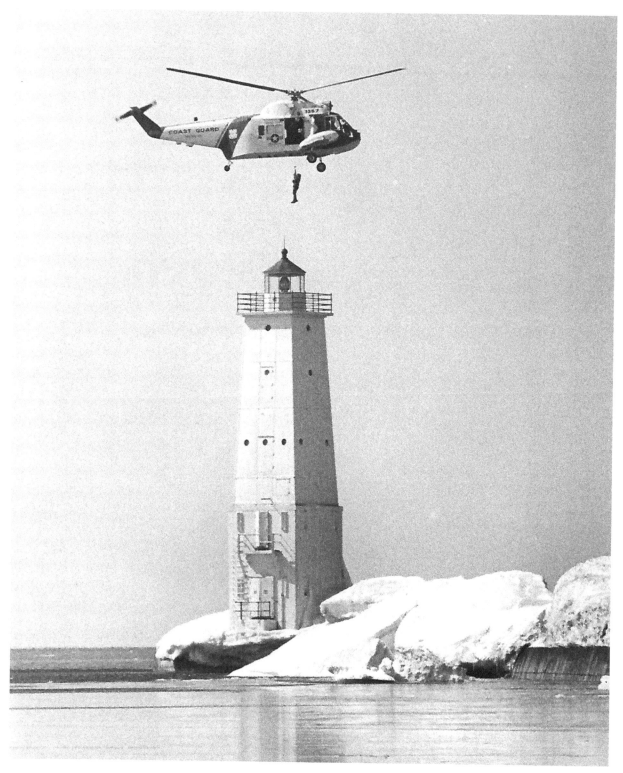

Lighthouses of Lake Michigan

Driving to the waterfront in Frankfort in late winter of 1987, I saw a Coast Guard helicopter lifting a technician from the lighthouse on the north pier. As usual, I had a camera near me in the car, set for the proper exposure; I quickly took the photo from the window.
I am always ready to shoot the next frame.

144

(Right) Here's an image of the USCGC *Biscayne Bay* moving slowly alongside the North Manitou Shoals Lighthouse, famously known as The Crib, the term for its foundation, filled with concrete, timber and rock. The steel lighthouse was decommissioned and closed in 1980, so I traveled with George Grosvenor on the Manitou Island Transit ferry to record the event.

The Crib was the last manned offshore lighthouse in the Great Lakes and operated by the U.S. Coast Guard when it closed. Three crew members and land furnishings were removed, but the light – which became fully automated–shines on. For decades, it has helped shipping traffic avoid the shallow shoal in Lake Michigan's narrow Manitou Passage.

The Crib was purchased by four families at a 2016 auction. They formed a nonprofit – The North Manitou Light Keepers – and renovated The Crib, making it viable for summer tours.

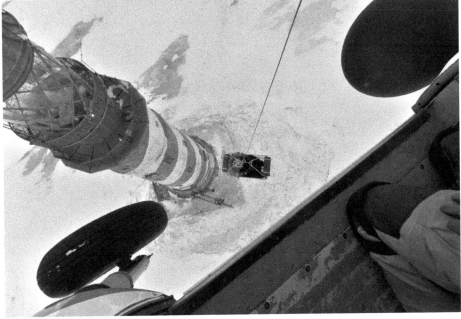

(Above) In mid-winter, I was belted in and shot this photo over the flight crew's shoulder as we hovered mere feet from the light tower. It's a little hard to discern what's going on, but Sean Roetnl, a Coast Guard petty officer, was lifted from the deck of the White Shoal Lighthouse in upper Lake Michigan in February of 2019 after performing maintenance and repair. This lighthouse is now privately owned. Although the Coast Guard no longer operates lighthouses, they are still responsible for their maintenance.

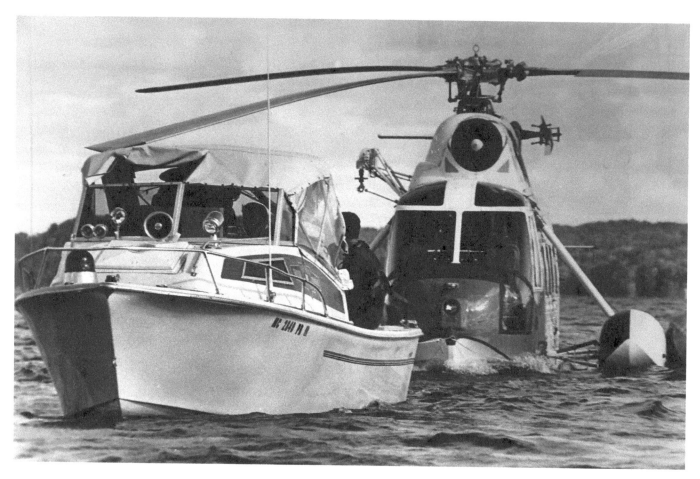

Helicopter Tow

On a fall day in 1983, Grand Traverse County Sheriff's marine patrol boat towed a disabled HH-52 Coast Guard helicopter to an East Bay launch ramp after the helicopter was forced into an emergency water landing due to a mechanical malfunction. I heard the call on a police scanner. The helicopter was later towed along county roads back to the air station, its blades folded back for safety and clearance.

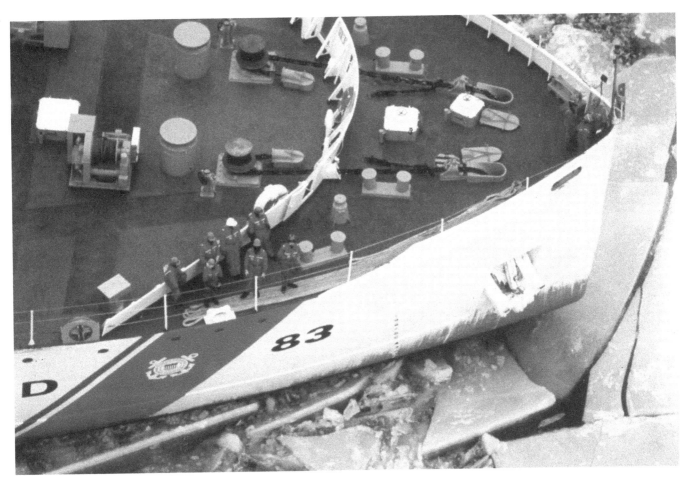

Soo Locks Cleared of Ice

The USCGC *Mackinaw* WAGB-83 opens the Poe Lock in Sault Ste. Marie, clearing ice from the lock, which is shut down each winter for 10 weeks for maintenance. Ice and snow accumulate through the winter until the late March opening of the shipping season and the locks need to be ice-free. I was hanging out the door of a helicopter with a gunner's belt on shooting directly below me. This is a favorite image of mine of the retired ice breaker.

Stacked Just Right

I have been honored to work with the U.S. Coast Guard for five decades, and they know
I am ready for anything they might need in way of images. At their request, I shot this photo
of three of the station's helicopters for a magazine cover in 2016. The pilots radioed
each other to get the alignment perfectly correct. Very talented pilots.

The photo was taken in the summer of 1975, during the Cherry Festival.

For more than 50 years the Unites States Coast Guard has flown me on numerous breaking and upcoming news events. Air Station Traverse City has supported my efforts, many times on the spur-of-the-moment phone calls. I've shot shipping, lake patrols, pollution patrols, lost people in the woods and on the lakes, ice patrols and dam removal.

The Coasties are a diverse and passionate team. As crews changed, commanders moved to new duties and new crews arrived, all have been part of the years of history captured here. Many became and still remain good friends. I am fortunate to have this relationship with all of them.

WEATHER AND SKY

Ice Caves

The winter was hard in 2014 with high winds and sub-zero wind chills. Low water levels in the Great Lakes and a winter storm created the perfect conditions to create a labyrinth of ice caves and cliffs: high winds pushed huge sheets of ice, freezing water and snow onto the shallow drop-offs along the Leelanau shoreline of Lake Michigan.

An immediate and impressive response made the Leelanau ice caves a destination for crowds of people, intense media coverage, and a popular book by Ken Scott. I planned a morning excursion to view and photograph the ice caves, a once-in-a-lifetime natural wonder.

See Ya ... in 6,700 Years

The universe constantly amazes me and in March 2020, the cosmos sent us a far-flung
visitor – Comet NEOWISE. It was the brightest and most easily viewed comet I've ever seen.
Discovered by the Wide-Field Infrared Survey Explorer space telescope, it remained in our
skies all night through late July above the 45th parallel. It will return again to our region
of the cosmos in 6,700 years. Wish I could be here to see it.

Spiced Ice Balls

After rolling ashore, balls of ice were covered in sand during an early winter snowstorm in Elk Rapids in 2019. The basketball-sized ice balls were formed from the action of rolling waves and snow over cold water. They looked like they were sprinkled with cinnamon sand and good enough to eat.

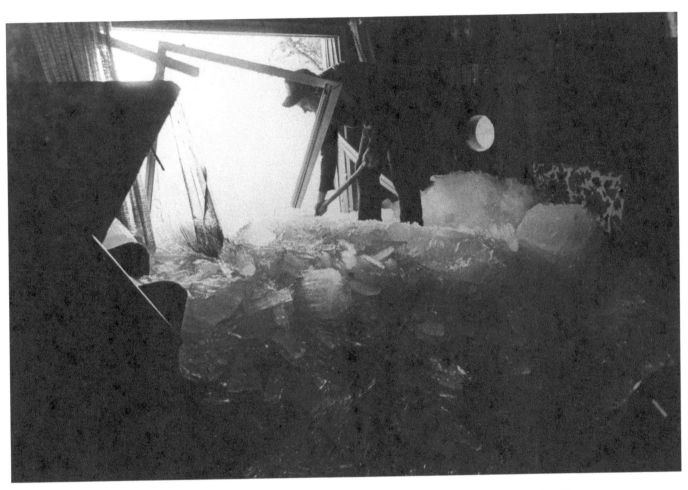

Iced In

Bud Weede stood on the back of a sofa in his East Grand Traverse Bay cottage in April 1979.
High winds had pushed ice off the bay into his living room. He shoveled it back out through
the picture window where machinery waited to remove it. There were no injuries from
the storm, but water and structural damage meant a lot of rebuilding.

2015 – A One-Hundred-Year Storm

A violent windstorm charged across Lake Michigan on August 2, 2015, tearing down hundreds of trees and demolishing buildings and vehicles across the northwest region.

Hardest hit was Glen Arbor and the Sleeping Bear Dunes National Lakeshore, where countless vacationers and residents found themselves stranded. Injuries were minimal, but property damage was severe and took months to remove fallen trees and repair or rebuild structures.

(Above) Large pieces of a fallen tree were removed on Wayne Street in Traverse City by city crews a couple of days after the storm. Many trees were replaced throughout the city, which is officially designated as Tree City by the National Arbor Day Foundation.

A repair crew discussed how to remove a large oak tree from a crushed roof
on Monroe Street on Traverse City's west side.

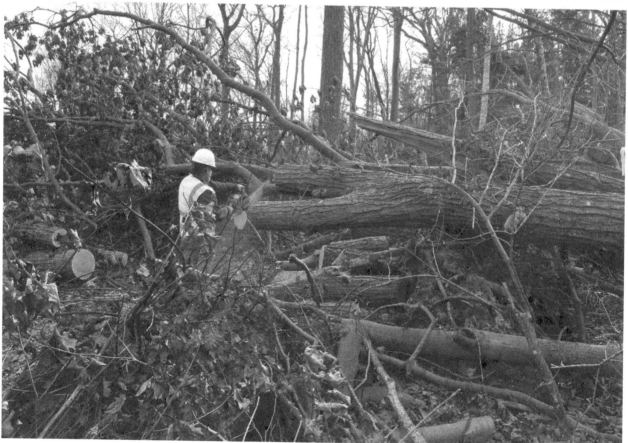

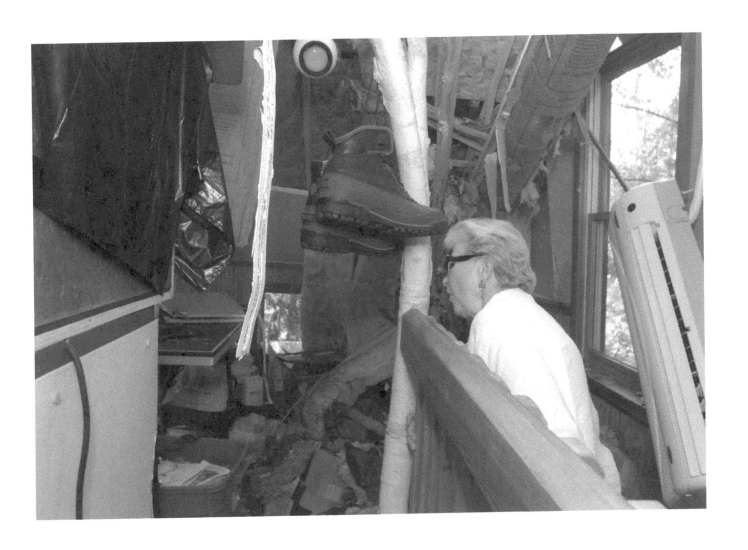

(Above) Carol Worsley, 77, of Birmingham and Glen Arbor, viewed the remains of her office above a garage at the bed and breakfast in Leelanau County. When the storm hit, she heard wind blowing and hail on the roof and headed to the stairs to leave the upper office. Two trees hit the building, knocking her down the flight of stairs where she was unconscious for a few minutes. Suffering a concussion and bruising, she fortunately was not badly injured.

(Facing page, top) Alligator Hill, a hiking moraine in the Sleeping Bear Dunes National Lakeshore, was devastated by the storm, with hundreds of trees torn and ripped apart. Some hikers, trapped by fallen trees, were luckily uninjured.

(Bottom) Crewmen with the Sleeping Bear Dunes National Lakeshore cut fallen trees from hiking trails on Alligator Hill near Glen Arbor. Park policy is to clear trails but leave all else untouched as nature left it.

Flooding at the Pier

Record-high water levels on the Great Lakes flooded the river walk in downtown Traverse City in 2020, covering the boards every time winds came from the north and pushed water up from the Boardman River to well beyond Cass Street. I watched the levels rise for over a year before receding, making the river walk once again walkable.

Flooded

In May 2020, two dams on the Tittabawassee River in Edenville and Sanford failed after heavy rains. The flooding and property loss was extensive and will take years to recover and rebuild. The *Detroit News* sent me to cover the tragedy. Downtown Midland's Farmer's Market pavilion was ten feet under flood waters during this historic event.

It's New, But Can it Break Ice?

(Facing page) The U.S. Coast Guard took delivery of a new 140-foot bay-class icebreaker during the winter of 1978. Tests were scheduled to record the capabilities of the new ship on Whitefish Bay, with Traverse City's air station measuring thicknesses of the ice while the tug worked to break through.

I hitched a ride on a second helicopter and recorded the work, watching the ship back up to gain forward momentum to move through 24 inches of ice. The ship more than passed, crushing two feet of fresh, new ice. Several of these ships are presently working on the Great Lakes.

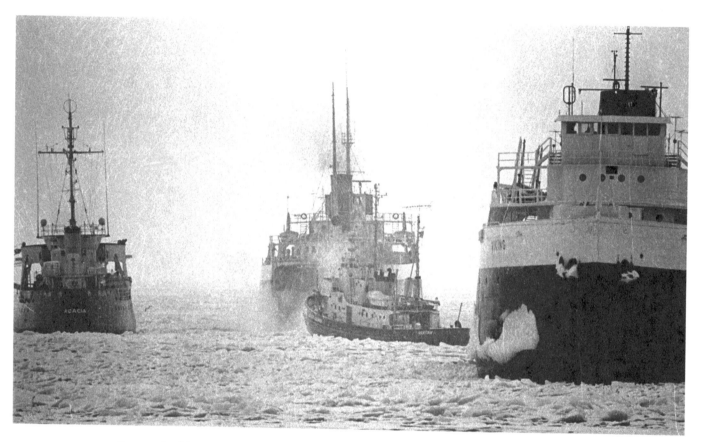

Entrenched in Ice

For decades, car ferries carried vehicles and railroad cars from Frankfort, Michigan, to Kewaunee, Wisconsin. The cross-lake service many times would get stuck in heavy ice at the mouth of the Betsie River in Frankfort, slowing or stopping the ferries.

In 1978, on an exceptionally cold and snowy winter day, the *Viking* (right) and her sister ship, the *City of Milwaukee*, became stuck in 20 feet of ice at the entrance to the Frankfort harbor. A tug and a buoy tender also became stuck when trying to free the ferries, but eventually all were freed and set on their way.

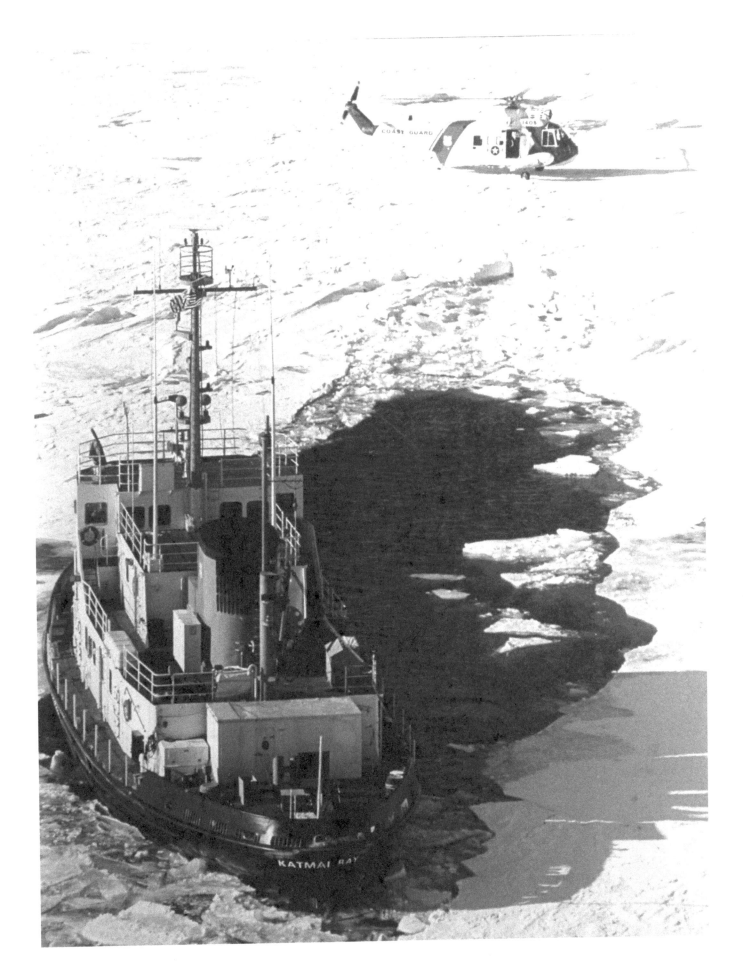

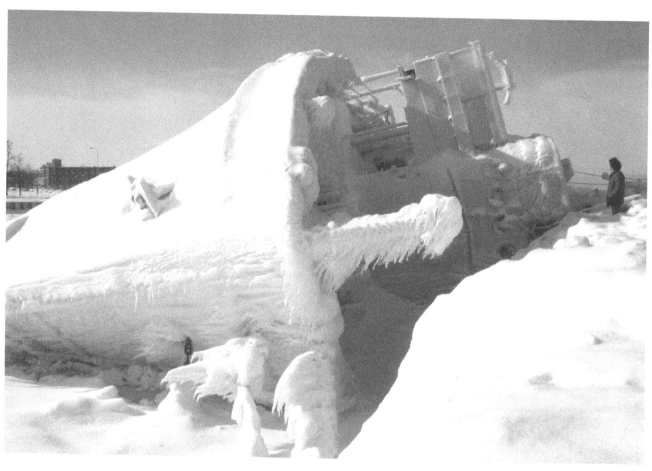

This Side Down

A winter gale packing high winds, snow and the lowest pressure system ever recorded over the Great Lakes hit the region in late January of 1978. The Great Lakes Maritime Academy in Traverse City featured two training vessels, the *Hudson* and the *Allegheny*, a former Navy ship. Both were tied to the east-west pier at the school. North winds pushed high waves over the break wall, as no ice had formed on West Grand Traverse Bay by late January, which would have protected the vessel. Hammered by freezing spray, the vessel capsized against the pier during the night.

I was living on East Grand Traverse Bay, and by midnight the storm had blown 28 inches of snow into two-story high drifts, effectively closing schools, roadways and businesses for three days. I skied down Front Street heading west toward downtown at 5 a.m., the only photographer working at the *Record-Eagle* at the time. Not a soul was moving, no cars or traffic and absolute white-out conditions. With goggles and snow gear for winter protection, I skied up the drive and saw no ship. It had capsized against the pier, showing only the bottom of the vessel. I returned in daylight for the first images to be taken. Marty Lagina posed with the stricken vessel in what became the most published image of my career. The vessel was righted and salvaged in May 1978 and now works as a towing vessel in the lower St. Clair River.

The day after the Blizzard of 1978, an anonymous male voice contacted me at the newspaper, telling me I should return to the *Allegheny*, that something had changed. Footprints leading to the vessel showed that someone had traversed the ice to leave a message on the hull. The image may be the second most-published when it went out on the UPI wire.

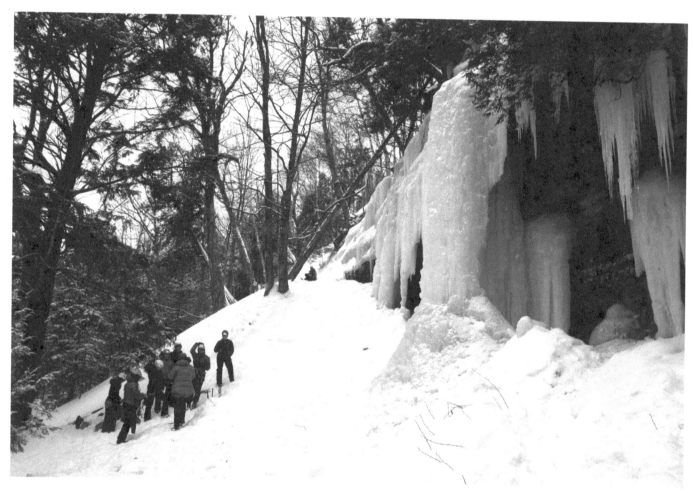

Climbing School

In 2018, ice climbers gathered at the site of frozen waterfalls Pictured Rocks during the annual winter Michigan Ice Festival near Munising. I covered the event for the *Detroit News* in a story and pictures, capturing spirited climbers of all abilities during the festival, which lasts five days each February. Their passion is deep; with all kinds of different ice features – crevices, depths, height, and steepness – the climbers must be well-equipped and ready for anything.

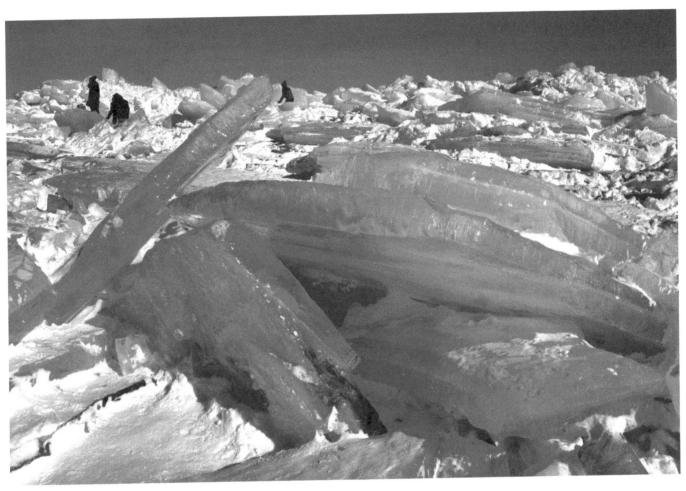

Blue Ice

Huge sheets of wind-driven, broken ice piled up on the shore in Mackinaw City in February 2021, the ice reflecting the blue tint of the sky. Hundreds of camera-toting visitors traveled to the Straits to capture the phenomenon, making a nice story for the *Detroit News*.

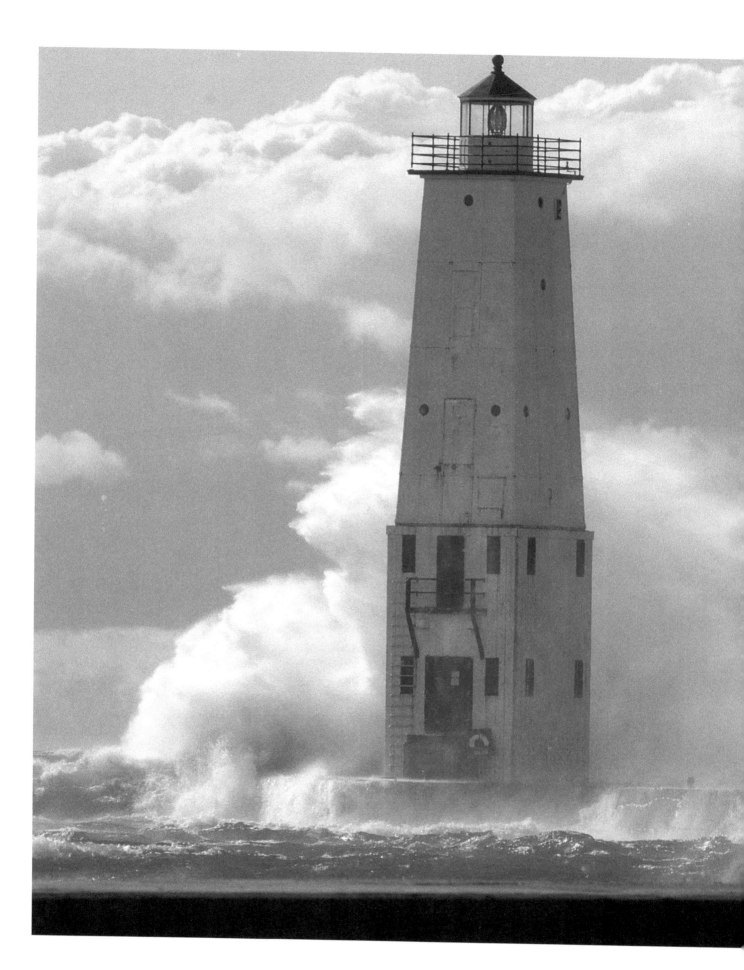

Surf's Up

When winds on Lake Michigan stirred up the lake in 2010, surfers appeared at Frankfort, where the waves reached several feet high. Walking out on the pier in wet suits, they waited for the water to rise and jumped over the rocks to surf. I stayed on shore and shot the photos with long lenses; it's dry and much less risky.

A LIFE-CHANGING PANDEMIC

An Empty Highway

M-72 in Williamsburg was devoid of traffic for the first months of the year 2020. Workers stayed home and drivers ceased or slowed deliveries, owing to the disrupted supply chain.

Out of Stock

Sorry for the inconvenience

Thank you for your patience

Stock Type 44 MS5144

Hoarding and the Toilet Paper Wars

The Great Lakes Tissue Company hosted a community drive-through sale on Wednesday, March 18, 2020, at their warehouse. Vehicles lined up for three blocks waiting to buy up to five enormous boxes (96 toilet papers rolls per box) for around $20 – a real bargain. Over 7,000 boxes were sold out by early afternoon.

(Facing page) Sarah Fitzak stuffed her Mercedes C300 sedan with hundreds of rolls of toilet paper, filling every nook and cranny. I silently wondered who could ever need that much toilet paper.

(Above) These shelves at Meijer were wiped out of disinfectants.

Here This Morning … Gone This Morning

Paul Martin posed with a pallet full of toilet tissue at the Acme Meijer store as he restocked the empty shelves. Anxious customers, fearing prolonged shortages, cleaned out the shelves within hours, intent on stocking up toilet paper and other common household items.

Free Meals

A food truck passed out free meals at the Salvation Army for months, providing nourishment to anyone in need of food during the pandemic.

(Below) Bags of pre-packaged breakfasts and lunches were passed out at Traverse Heights Elementary School in April 2020, providing thousands of free meals to students in the Traverse City area.

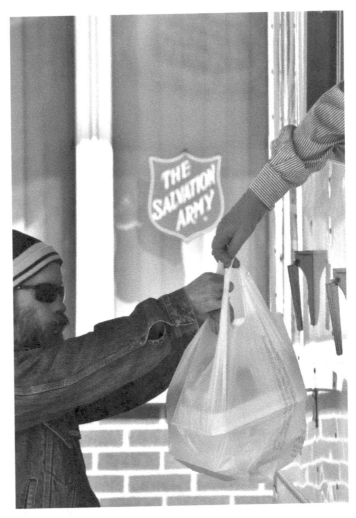

And May I Wash Your … Pump Handle?

An attendant at the Costco gas station in Traverse City wiped down a pump handle, a sterilizing task performed in the earlier months of the pandemic after each customer had fueled their vehicle.

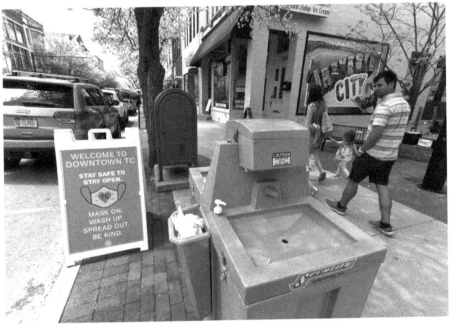

Stopping the Spread

The Grand Traverse County Health Department provided free COVID-19 testing
in the parking lot of Traverse City East Middle School in July of 2020. Hundreds of cars lined
up to take the uncomfortable swab test to see if they had the virus. I wish I had
my drone to capture the sheer number of vehicles.

Hand-washing stations were placed around the downtown area of Traverse City
to allow anyone to wash hands to avoid contracting the COVID-19 virus.
This photo was taken on Memorial Day 2020.

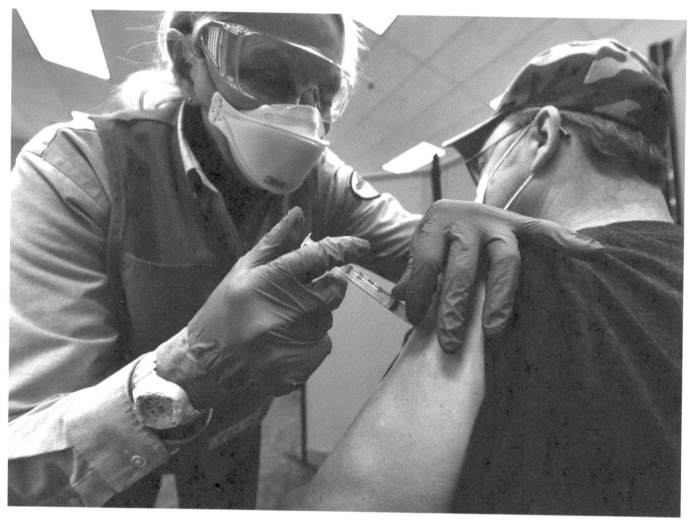

Vaxxing Victors

Laurie Collier, a registered nurse, vaccinated Calvin LaMatheny of St. Ignace at a Saturday clinic on February 6, 2021, at St. Ignace's Little Bear East Arena. The Moderna vaccine was administered to 480 Upper Peninsula residents over the age of 65 with a second vaccination to be given in early March.

(Right) A Traverse City pharmacist loaded a vaccination needle, preparing for a free inoculation clinic in 2020 at Munson Medical Center.

(Below) Beverly Marrison, 84, was another of the 480 seniors to receive the Moderna vaccine at St. Ignace's Little Bear East Arena. The Michigan Army National Guard was a big part of this effort, including Sgt. Robert Lackey, who administered Marrison's shot.

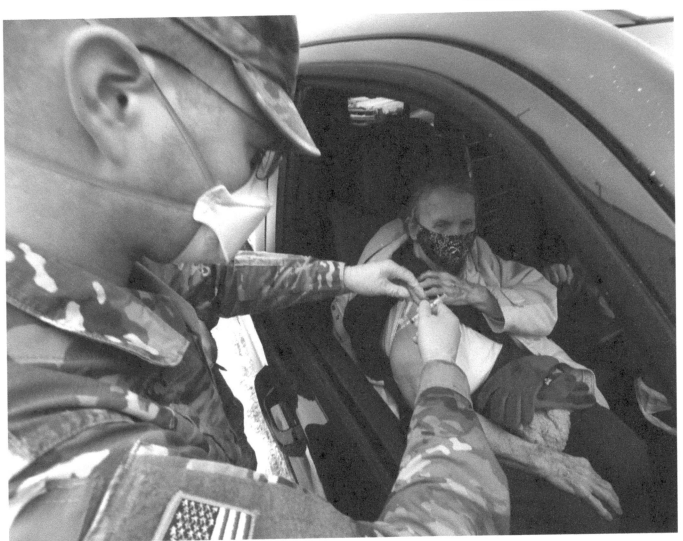

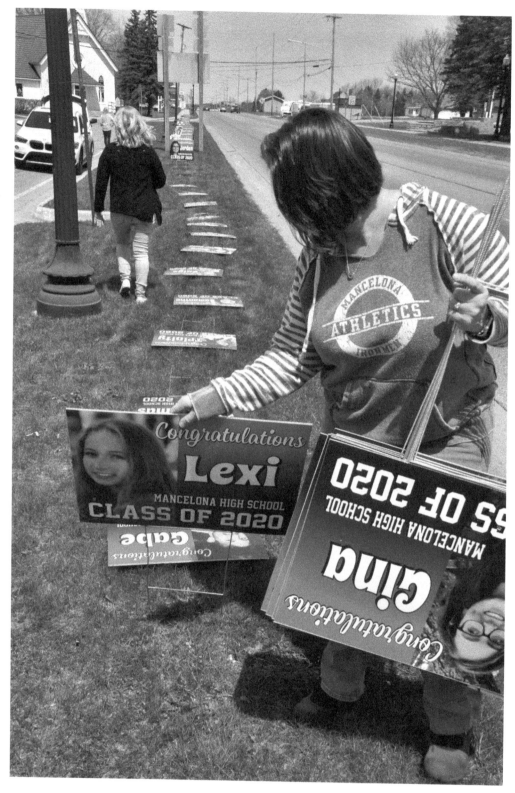

Honoring Graduates

Parents of 2020 Mancelona high school graduates placed signs along US-131, celebrating their children's graduation for all to view. Most all traditional in-person graduation ceremonies were canceled due to the virus.

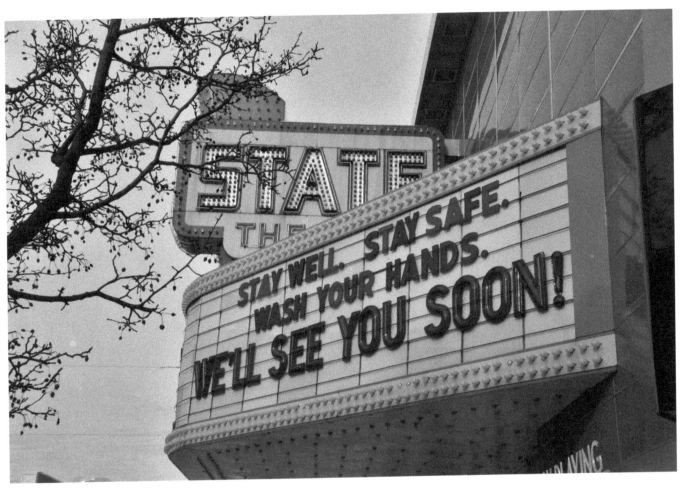

The State Theatre Closes

The State Theatre in Traverse City posted various messages on their marquee encouraging people to do what was necessary to survive the virus as it spread through the region. The movie house was still closed as of September 2021.

ACKNOWLEDGEMENTS

The idea for a book of five decades of photography has grown over several years in which I have edited, scanned or viewed more than 84,000 images.

My photographic career has been exciting, emotional, and deeply rewarding. I owe much to the people who helped me along the way.

First, a heartfelt thank you to the student photographers at the *State News,* the MSU student newspaper. You inspired me, taught me the ropes, and became lifelong friends.

To the late Bill Gallagher, a Pulitzer Prize-winning photographer with the *Flint Journal,* with whom I spent time in the press box at Spartan Stadium; Dennis Kinsella with United Press International in Lansing; the photo editors at the Associated Press and Carlos Osorio, AP's Michigan photo editor. Thank you all for your support.

To the late Tony Spina, my mentor early in my career and to the staff at *The Detroit Free Press,* your support has been deep and appreciated. To the photo department at *The Detroit News* and news editors who have bolstered my work with their support and input and have taught me much about writing, thank you.

I have learned much from photo editors with the *Chicago Tribune,* the *Grand Rapids Press* and the *New York Times.*

Mr. Ed Kline, my first editor at the *Traverse City Record-Eagle,* who believed in me and gave me a position to grow. To so many editors and publishers over the decades, thank you.

Members of the Michigan Press Photographers Association invited me onto their board for three decades and inspired me with their work and support – keep up the inspiration for the members both young and veteran.

Thank you to the photographers and darkroom staff at the *Traverse City Record-Eagle* who put up with me through thick and thin: Dann Persyk, Keith Vandervoort, Chris Mikula, Ken Smith, Sarah Neal, Eric Sherberneau, Greg Johnstone, Jodee Taylor, Kristine Dittmer, Minnie Wabanimkee, Jim Bovin, Doug Tesner, Heidi Gregory and Elizabeth Conley.

A special nod to the late John Hawkins, a photographer like no other, you were a great friend and mentor and are missed.

Thank you to *Record-Eagle* editor Nate Payne and publisher Paul Heidbreder, who opened the archives at the newspaper so I could search through the print files and negatives.

To the people of northern Michigan, firefighters, Coast Guardsmen, first responders, shop owners, workers, volunteers, city and county employees, and athletes – you are this book. Thank you!

To Mission Point Press editor Anne Stanton, Doug Weaver and Heather Shaw, I could not have begun this adventure without your knowledge and belief in this project. Thank you.

And, finally, to my wife and partner, Meg Russell, this book is dedicated to you. I couldn't have accomplished this without your love and support.

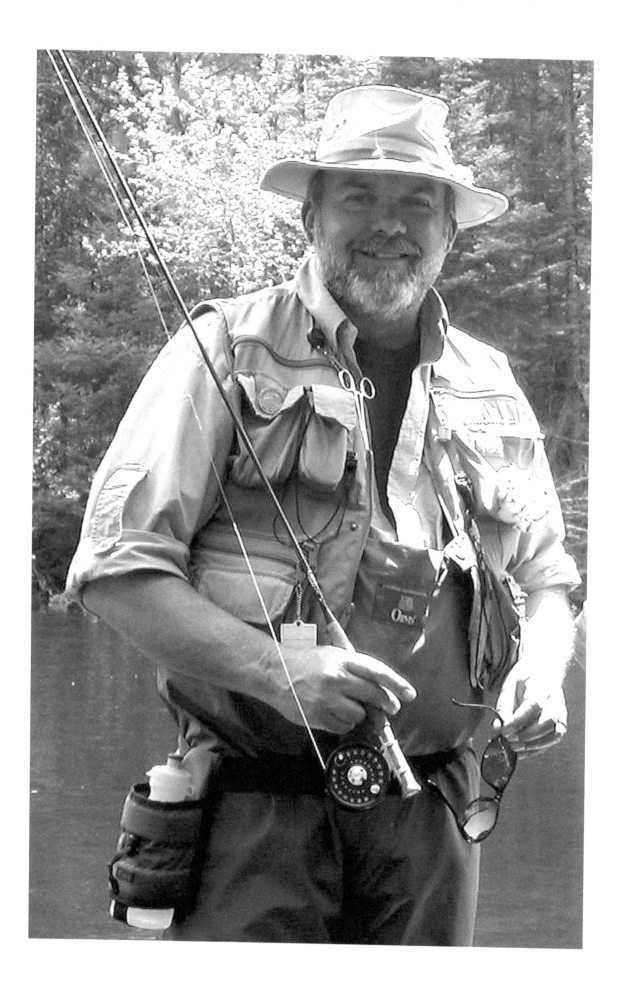

Born and raised in Traverse City, John Russell began using a 35 mm Argus camera at the age of eight, and developing film in his grandma's basement not long after.

After working at a cherry orchard as a teen, he found a job more suited to his skill set – shooting photos for the *State News* at Michigan State University, where he earned a bachelor's degree.

Russell returned to his hometown, working as a photographer for the *Traverse City Record-Eagle* from 1975 to 2004. He now freelance shoots and writes for the *Detroit News*, as well as shooting for BRIDGEMI, online news sites, and wire services.

John and his wife, Meg, own Great Lakes Images, a freelance photography business and image library.

In his spare time, he fly-fishes, ice boats, and volunteers. He is active with the Mid-Michigan Honor Flight, Anglers of the Au Sable, the Twin Bay British Car Club, the Traverse Area Camera Club, and the Grand Traverse Ice Yacht Club. He has also served on several boards, including the Grand Traverse Bay YMCA.

John shares his life with Meg and their family, including a new great-granddaughter. Two rescue dogs, a cranky rooster, and plenty of work on their Williamsburg farm make his life complete.